P9-DOB-394

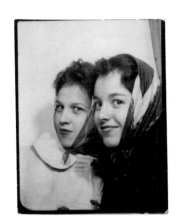

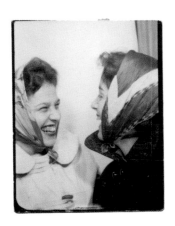

AMERICAN PHOTOBOOTH

Näkki Goranin

Foreword by David Haberstich

W. W. Norton & Company
New York | London

American Photobooth
Näkki Goranin

Copyright © 2008 by Näkki Goranin
Foreword copyright © 2008 by David Haberstich

All rights reserved.
Printed in Italy.
First Edition.

The text of this book is composed in Nexus with the display in Interstate.

Digital captures by Stephen Stinehour.

Book design and composition by Laura Lindgren.

Manufacturing by Mondadori Printing, Verona.

Library of Congress Cataloging-in-Publication Data
Goranin, Näkki.
 American photobooth / Näkki Goranin ; foreword by David Haberstich. — 1st ed.
 p. cm.
 ISBN 978-0-393-06556-5 (hardcover) — ISBN 978-0-393-33076-2 (pbk.)
1. Portrait photography—United States. 2. Photobooths—United States.
3. Self-portraits—United States. I. Title.
 TR680.G68 2008
 779.092—dc22 2007039273

W. W. Norton & Company, Inc.
500 Fifth Avenue
New York, N.Y. 10110
www.wwnorton.com

W. W. Norton & Company Ltd.
Castle House
75/76 Wells Street
London W1T 3QT

1 2 3 4 5 6 7 8 9 0

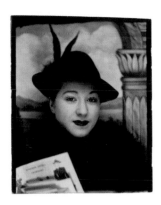

*This book is dedicated to
the memory of my mother,
Lydia Goranin Schaffer*

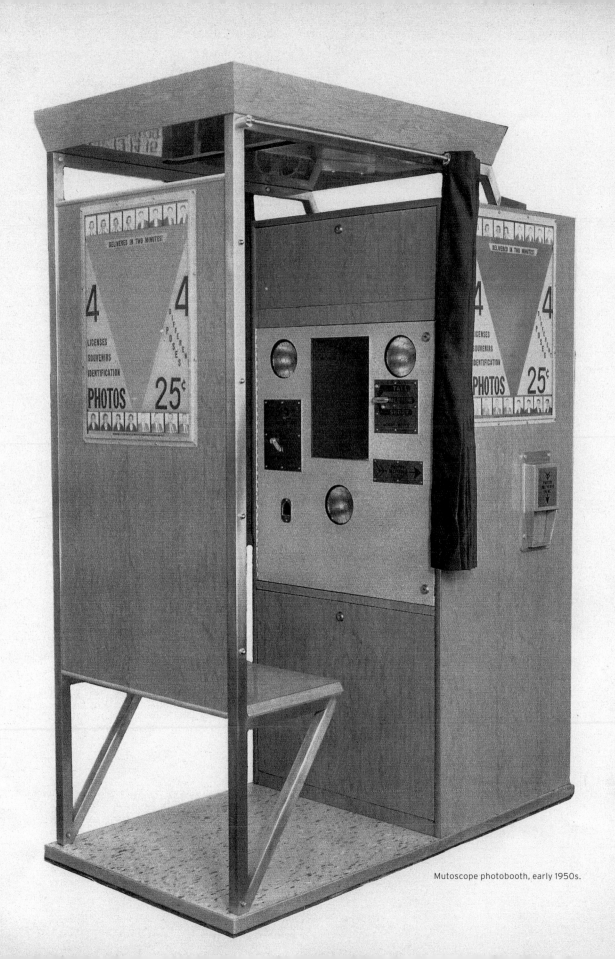

Mutoscope photobooth, early 1950s.

CONTENTS

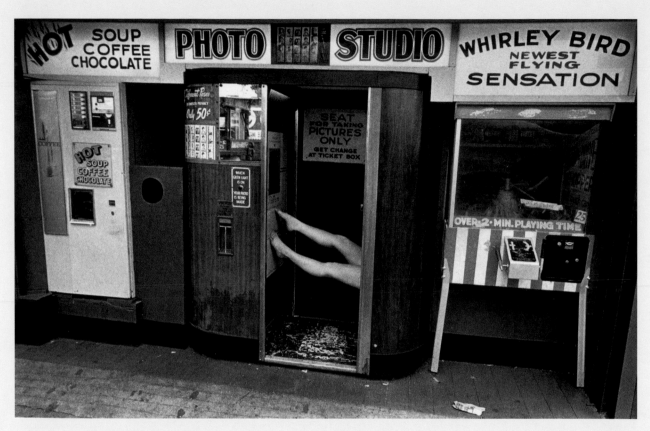

Photobooth, Coney Island © Harvey Stein, 1978.

FOREWORD The Automatic Photobooth in Context(s)

DAVID HABERSTICH *Associate Curator of Photography*
Archives Center, National Museum of American History,
Smithsonian Institution, Washington, D.C.

Scholars like to label epochs and other spans of time, just as we all need to label or name palpable objects. We had our Bronze Age, our Medieval Age, and our Renaissance, a Space Age, an Information Age, etc. Somewhere among those periods was a Machine Age, and perhaps the Space Age and the Information Age overlapped it; these are not neat divisions. Or perhaps they are subsets of our Machine Age. The term may connote a preelectric, preelectronic, predigital era of primarily mechanical devices, relying upon the power of wind, water, and muscle to operate them. Yet gasoline-powered vehicles are almost emblematic of the Machine Age in the Futurist manner that horse-drawn buggies and other wheeled vehicles were not, despite the fact that, strictly speaking, they are basic machines of the classic type studied in high school physics. Yet these labels are imprecise, and the most sophisticated products of the age of information are still fundamentally machines.

The camera too is a machine, although the earliest cameras were little more than boxes with few, sometimes no, moving parts. In Francis Picabia's 1915 "portrait" of Alfred Stieglitz, *Here, This Is Stieglitz, Faith and Love*, the great tastemaker and guru of modern art and photography was caricatured as a battered and broken folding camera. However uncomplimentary that depiction, many great photographers have considered their cameras to be extensions of themselves. Yet controversies erupted periodically over the dubious capacity of such a mechanical device to produce art. Certainly the humble and homely automatic photobooth seemed to question the pretensions of artist-photographers such as Stieglitz,

who had managed to convince aestheticians that machines could indeed serve as extensions of the artist's eye, mind, and soul. It hardly need be emphasized that the entrepreneurs who devised and marketed automatic photobooths were not particularly interested in art theories. These booths were vehicles of commerce. As we shall see in this book, however, the blatantly commercial photobooth has also occasionally yielded great pictures.

We might consider the automatic photobooth part of a long line of faintly amusing devices that were intended to be self-sustaining with only infrequent human attention. Some, like Rube Goldberg fantasies, merely demonstrate that human brain and muscle power can design and build complex, clever machines, which serve as substitutes for human effort. The automatic photobooth was a labor-saving device that presumably would be cheaper to employ than a live photographer. But it was envisioned as more than that: it would attract users by its clunkily attractive novelty as well as its convenience and low cost. Perhaps this is as good a place as any to suggest that the form of the automatic photobooth, and the relative privacy that attends its operation, might well remind one of an outhouse or privy, and that there might be some vague similarity between the experiences one might have therein. Is the solitude of the photobooth precisely one of its most basic attractions?

Before going further, however, let us agree that the automatism of the "automatic" photobooth is relative or partial. What is automatic is the processing of the photographs after the subject/photographer has initiated the cycle with a small financial investment. The subject/photographer, not the machine, is in partial control of timing, pose, and expression. (The "automatic photobooth" is a far cry from the fully automated robotic camera we might well imagine, ranging across the countryside and snapping pictures either in random mode or in a programmed search for specified types of subject matter it might detect with its various instruments—or somewhere in between. I thought we should clear that up.)

People have long been fascinated with the idea of machines that could operate without human intervention. Sometimes phony machines have been designed to entice the gullible into parting with their money as easily as they would at carnival attractions. When I first studied the history of photobooths many years ago I came upon claims that some early booths were not automatic machines at all, that little men crouched unseen inside the chambers, furtively processing photographs the old-fashioned way, while amused customers believed the machine was doing the work. Such a peculiar subterfuge would be pointless unless the novelty

of automatic operation could attract high-volume use sufficient to pay the hidden operator—before the novelty wore off or until the pseudo-robot technician sneezed or otherwise blew his cover.

While various kinds of commonplace mechanical devices (and eventually electrical or electronic machines) have for centuries assisted humans with their work, what produces excitement and awe is the automatic, self-operating machine that performs complex activities but requires human intervention only for stopping, starting, and maintenance. Medieval automatons fascinated viewers because they were clever machines that mimicked human motion; nowadays we are attracted to robots, whether in humanoid R2D2 form or not at all humanlike. Self-operating machines need not have an anthropomorphic appearance to intrigue us: they just need to perform a mundane human activity. Recently a man invented a highly complex machine that does nothing but tie a necktie, apparently just to prove he could do it, for it has no practical application: what man would trust a machine to tie his tie for him? ("Now, Hal, not so tight…") The necktie machine awes observers through its very intricacies, which insinuate the astounding levels of complex thought and calculation, precision, insight, and plain hard work required to build a machine that can replicate a sequence of ordinary human motions. No matter how cleverly the machine was designed to do its work, its profligate, absurd expenditure of labor clarifies the obvious: the human body is more intelligently designed—pardon the expression—to perform the task.

Näkki Goranin's diligent research has uncovered the technological and commercial history of the automatic photobooth as well as the social context in which it was developed. The absorbing history is supplemented by a sampling from the trove of mesmerizing photobooth images she has collected over the years. Many images in this book portray the loneliness of solitary figures, testimonies to the human condition, preserving sad moments, in fleeting or permanent features. Some of the grimmest are the most memorable, the most strangely beautiful. It is a truism that words cannot describe them adequately; we can only imagine the circumstances under which the subjects depicted themselves, whether deliberately or candidly, in these guises. Others, however, have the opposite effect, with a sheer zaniness that is infectious. Photobooths have helped many customers find and capture their inner comedians, nudging the staid to loosen up. For anyone who assumes that photobooth pictures are perfunctory, utilitarian records at best, the range of emotions and moods portrayed by the subjects of the Goranin collection is a revelation.

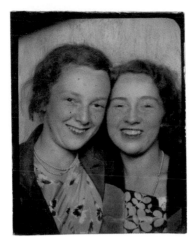

Example of untrained tinting, 1930s.

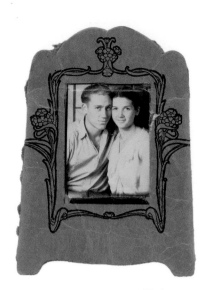

ABOVE AND OPPOSITE: Photo-movette photos with paper frames.

Indeed, this compilation of images virtually defines the art or the aesthetic of the photobooth, for lack of a better term. The author has selected her images with great care and acumen. They record not the encounters and collaborations between two persons—a subject and photographer—to be analyzed and decoded in the way of the traditional photographic portrait in which a human photographer ultimately manipulates the subject in some manner; instead they portray an encounter between a solitary human and a dumb machine. Or is it in its purest sense a dialogue between the subject and the self in which the machine merely serves as a conduit or facilitator? The self-portrait is perhaps the rarest, the most elemental, the most poignant and mysterious of all artworks. Even the funniest pictures in this book are imbued with that mystery. Näkki Goranin has performed an enormous service to photography in compiling this wonderful book. An artist of the photobooth herself, she is hardly the first, for other artists have turned this humblest and tackiest photographic instrument of commerce into an art machine, Andy Warhol perhaps most famously. Twenty years ago I was delighted by the provocative yet profound work of George Berticevich, who asked women to photograph themselves disrobing in a photobooth, thereby functioning as a conceptual artist to "interrogate" and confound my very assumption that the photobooth records a dialogue with the self.

The "snapshot" mode of photography has long been recognized as having enormous significance, not just as the chief vehicle for preserving memories and personal and family history but as a fundamental genre in the art of photography. The photobooth snapshot is a very specific, ritualized form of snapshot, which requires a different kind of analysis and interpretation, its small size and technical imperfections—and perhaps its stigma—frequently causing observers to disregard it. The photographs in this book are a testament to the visual power of a true connoisseur, who saw what most of us might have missed.

Photographic technology helped to free artists from most of the skilled manual labor traditionally required by art making so that they could concentrate on both perception and conception. We now have a well-documented, solid, critical history of the photographic medium, and (most) art historians take photography seriously. Nevertheless, we are not too smug to admit that the fact that meaningful works of art, especially portraits, can be teased or wrung out of a machine like a camera sometimes still seems like a kind of miracle. That the camera might occasionally be in the form of a do-it-yourself, drop-coins-in-the-slot, sit-in-the-box commercial contraption seems yet more miraculous, even if it confirms our

broad, enlightened notions of what art is. That a perceptive, dedicated, sensitive artist like Näkki Goranin has rescued from oblivion so many amazing self-portraits created by amateurs confronting themselves in the fleeting privacy of a humble, sometimes tacky photobooth is yet another miracle for which we can be grateful.

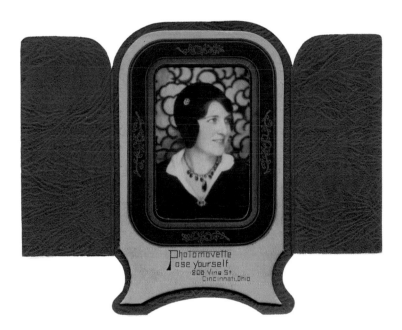

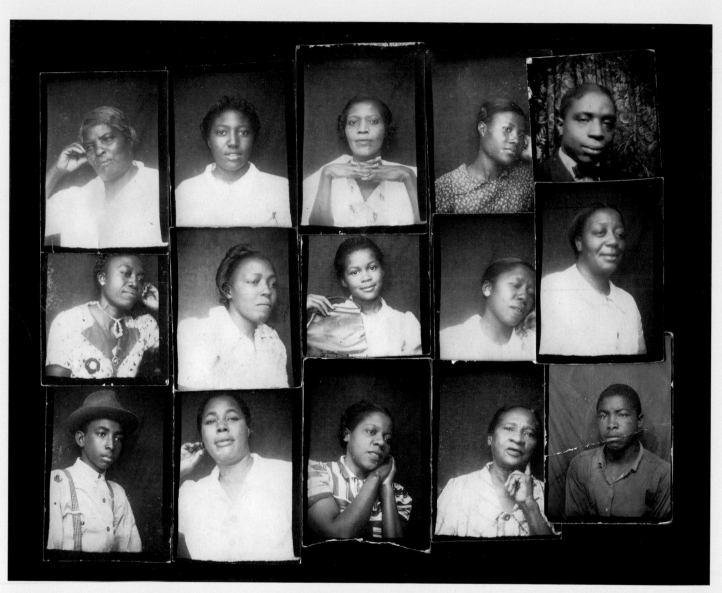

Typical page from a photobooth album, popular in the 1930s and 1940s.

INTRODUCTION The History of the Photobooth

How did all of these orphaned photos come into my life? For twenty-five years, I have been collecting all types of historical photos, which have influenced my time and vision in the darkroom. The past ten years or so I have focused on searching for photobooth pictures. These tiny time fragments can be found in garage sales and auctions and on the Internet. Like the forgotten images they are, it has been impossible to track down the original owners or their families. Traded, packed in old scrapbooks, outliving the smiling faces, all these photographs have finally found a home in this book.

When I first started the book, I was going to write a short ten-page history to accompany the pictures. I was concerned that I might not be able to find enough material for ten pages. Four years later, I have a history book and no place to put my photobooth art.

Putting thousands of miles on my car, I have tried to track down the last people who worked on the old booths, listened to fascinating stories in dozens of coffee shops, and saved historical photographs from Dumpsters.

Like all twenty-first-century explorers, my first step was the computer. At that time all I was able to find out was that a Siberian immigrant named Anatol Josepho had invented the machine. Then I moved on to the library to spend hours, days, and weeks going through newspapers, trying to find any acknowledgment of his life. I tracked down an obituary and found Josepho had died in southern California in 1980. Through the notice, and after many phone calls, I was able to locate people who had known and loved him. Here begins the real story.

THE PHOTOMATON

In 1894, Omsk, Siberia, was on the border, or the "gateway," to the cold interior of a beautiful but brutal land. This was also the year the first railroad connected Omsk to Moscow and China. Far from Moscow, Omsk was a city of exiles, intellectuals, politically minded citizens, and a significant number of Jews who had been less than graciously encouraged to move to Siberia.

In the struggling industrial town, Anatol Josephewitz (later Josepho) was born to a prosperous jeweler and his wife. At age three, Anatol lost his mother and developed a close and loving bond with his father. Even in the wilds of Siberia, at eight or nine little Anatol started to dream of traveling around the world, especially to America to see the "wild west." He also had a great interest in the little Brownie box cameras that were making photography accessible to the growing middle class. As a child, after seeing his first camera, he became intrigued and told his father he wanted to learn all he could about photography. Following this interest, Anatol's father enrolled his son in a local technical institute. Anatol was impatient, however. He had the heart and desire, as so many adolescents do, to break free and challenge himself. At the age of fifteen (about 1909), he told his father it was time for him to explore the world. His father, who seems to have been exceptionally encouraging and loving, told Anatol, "Life itself, my son, is the supreme teacher. Go. Travel. Work. Study. Listen. See. Understand. Fear no thing. Fear no man. Come back when you will. I'll still be waiting for you. And I want to be proud of you when you come back. Remember that, my boy, won't you?" (This according to popular magazines in 1926.)

His father gave him money to go to Berlin, originally to stay with relatives. And what an adventure that would have been on the new train route. Taking a second-class ticketed train, fifteen-year-old Anatol would have been crowded in with all the other Russians bound for Bremen, Germany, to catch ships heading for North America and South America to begin new lives in lands without a czar or an oppressive economy. After several days on the train, making changes in foreign cities, the young teenager finally arrived at one of the most sophisticated cities in Europe. In 1909 the Aviation Exposition was demonstrating the Wright Brothers Flyer for the first time. The Shopping Arcade, one of the largest malls in Europe, was opening. Art, music, and photography were part of the daily life of Berliners. Walking into this new world was the more than eager Anatol. Almost broke from spending too much money on his journey, Josepho explored the city trying to figure out what he could do to survive. As Anatol walked through the

town, the window of a photography studio demanded his attention. Lined up in the window were beautiful photographic portraits, which had been hand-tinted. He was fascinated and felt his earlier interest in photography reawakened. With both courage and a warm, engaging personality, he walked into the studio and talked the owner into both hiring him and training him as a photographer.

Here fundamentally is where Anatol's life began to change. As he learned how to use a portrait camera and glass negatives, as well as the arts of developing and printing, he evolved the idea of creating a faster, more efficient, and less costly way of creating images that would make photographs available to the average working man. The idea was still in its gestation stage, but Anatol would focus and work on this idea for the next sixteen years.

The lure of all the America-bound people coming into the studio to have their portraits taken proved too much of a temptation and, in 1912, the eighteen-year-old, with money saved from his job, joined the parade of immigrants on a ship bound for New York City. The city was now a funnel for the expectations of disembarking passengers. Feeling overwhelmed, not able to find a job, and without any support, Anatol returned to Europe, only this time he went to the heart of the Austro-Hungarian Empire, to romantic and thriving Budapest.

With great optimism, the now experienced Josepho opened his own photo studio. At nineteen, he was his own person, experimenting with photography and starting to draw designs for an automated photo machine. Using his technical background from the Russian school, he wanted to create a machine that would employ an interior mechanical device that would be self-operated and initiated by a coin device. He worked on this plan with great devotion and came up with a primitive prototype of sorts, which he actually sold in Vienna for 50,000 kronen. (In today's market about $5,000 U.S.)

By 1914 changes in European geography were threatening. The Austro-Hungarian emperor was shot in Sarajevo and being both foreign and Russian in Budapest could be dangerous. Anatol could not leave Budapest to see his father and he watched the money he had earned and saved dwindle in the war economy. He was an alien during wartime, albeit a charming one.

As a Russian, Josepho was put under strict military surveillance. He could not go out shooting photographs and local people may have been reluctant to go to his studio. The young photographer, full of energy and ideas, had few patrons and much free time. Working on the development of the photobooth became his primary focus. He started thinking about creating a photographic paper that

would produce a beautifully toned positive image and not require a film negative. He would spend years figuring out how to use specific chemicals to develop this paper and how to efficiently design a delivery process that would be automatic. In addition, he started to think about how an inserted coin would trigger the whole process.

The idea of automatic photos was not entirely unknown. In Paris, a French photographer had produced a machine that took small photos. This process had numerous chemical problems and required constant maintenance. A similar machine, put out by General Electric, was also introduced in American and Canadian penny arcades and produced "penny photos." Ads appeared here and there for automated photo machines but these machines, too, required constant attention and still used primarily traditional photographic negatives and chemistry.

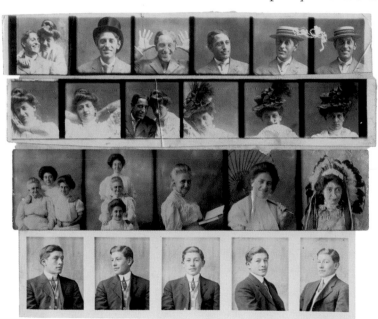

These four strips or "penny photos" were taken by turn-of-the-century automatic photo machines or penny cameras. These cameras were usually older models converted to produce small portrait strips.

Whether Anatol knew about these earlier semiautomatic machines or not is uncertain. In any case, by the end of the First World War, it was time to go home. Josepho had not seen his father in many years. Mail was undependable. Over the years, a friendship with another Russian exile, E. D. Locke, had strengthened Josepho's desire to try to leave. By 1919 central Europe was being reorganized. Distrust between the East and West was strong. Anatol, who did not seem to have much fear of anything, obtained forged passports and Austrian officers' uniforms for himself and his friend.

Anatol and Locke had three thousand miles to go and limited funds. Sections of train rails would have been destroyed. Roads would have had other dangers. Despite the problems they were journeying east. The majority of people were traveling west, to escape in the big migration to America. As the two young men traveled through Czechoslovakia (Bohemia), they would have noted that life had evidently changed. The warmth and casualness of everyday life was gone. The Czechs had risen against the *Bolsheviki* and the sense of danger, fear, and possible bloodshed was part of the young men's adventure. From Bohemia they crossed the border into Russia, to Odessa on the Black Sea.

But this was no longer the Russia that Josepho had left seven years earlier. They had to quickly get rid of their Austrian uniforms, destroy their forged papers, and find a way to get to Moscow on their trek home. Here their lives became more and more like an old Hollywood movie. They were arrested several times and, each time, at the risk of death, managed to escape, getting gradually closer to their destination. By the time they made it to the Siberian border, they had escaped the Bolsheviks many times. But now, on the border, they were captured by other nationals and thrown into prison in Perm. Prisons in 1919 Russia were brutal. Food, clothing, clean water—all were limited. Anatol, the patron saint of positive attitude, figured out a way to escape but encountered hand-to-hand fighting with guards, whom he and Locke luckily overcame.

The next two and a half weeks were desperate ones. The two young Russians had no maps, no provisions, and no warm clothing. Locke and Josepho had to travel at night, through the rough Siberian terrain of forests, bogs, and open, unprotected fields. With no dependable water source and no real food, every day became a test of survival. Finally, close to starvation, they were once more picked up and imprisoned by Bolsheviks in Tchelliebiask. In what should have been the worst of situations, Anatol's endurance, charm, and wit impressed his guards. After three weeks in jail, Anatol was able to convince a Bolshevik officer that they were not spies, not political contenders of any sort, but just two loyal Russians desperate to get home.

Josepho's golden personality not only won freedom for himself and Locke, but the officers also gave them two train tickets to Omsk and some survival money. Considering how desperate the Russian economy was at this time, it was an act of amazing kindness and camaraderie.

It was 1920 and Anatol had finally returned to his father and his home. But so much had changed. The Red Army had invaded Omsk in 1919 and life had become much more complicated. Anatol, having experienced the freedom of being on his own, could not resist the challenge and lure of being part of a bigger world. Saying good-bye to his father once more, not knowing when they would see each other again, Anatol left, only this time he took the train east. Traveling through Mongolia and China, he finally ended up in Shanghai in 1921.

Shanghai, China, in 1921 was known as the "Paris of the East." Though the city was an international mix of people including wealthy entrepreneurs, the local Chinese were struggling. This was the year the Chinese Communist Party was established. Drawn into the dramatic artistic hub, the twenty-seven-year-old

Anatol found a new challenge. He had changed his last name from the Russian spelling Josephewitz to the more generic Josepho. With money from home, he established the Josepho Studio and became quite successful. A popular photographer, he also journeyed through parts of China shooting images, but somewhere in the back of his mind he was constantly thinking about and working on the design of the Photomaton. In Shanghai, a serious blueprint was roughly drawn out and the notations for the chemical process carefully organized.

Anatol was now about thirty. His studio was a financial success. But still it was not enough. The idea of his automatic photographic machine drove him to new ambitions.

While I was in China, in 1921, I drew rough plans for the invention. I decided to come to America and hunt for backers. I landed at Seattle. It struck me that I ought to go to Hollywood and get motion picture experience. I went there, got the experience I needed, and then came east. I had relatives in New York City. With their aid, and that of friends, I raised what I needed to produce the first model. For that purpose, I raised $11,000. Incidentally, I may say that those who loaned me the money for an interest in the invention have been well repaid for taking a chance.

To understand how much money $11,000 was then, the average cost of a nice-sized house in 1925 was $2,000. Josepho the traveler, the immigrant, the charming inventor was invincible. Without connections or friends, he wandered into the Hollywood community and was immediately able to find work. He established a circle of friends, but knew he had to go to New York to fund his invention, so he worked his way from California to New York City, all the time carrying his cherished blueprints and formulas. He arrived in New York City with about thirty dollars.

In a short time Josepho, the newcomer, was able to talk people into loaning him money, find the appropriate machinists and engineers to help him build his Photomaton machine to his exact qualifications, and then, amazingly, be recognized and sought out by the top industrialists in America.

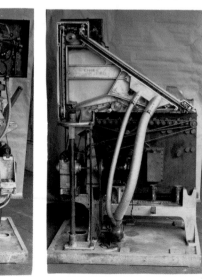
Internal Photomaton with metal cover, 1925.

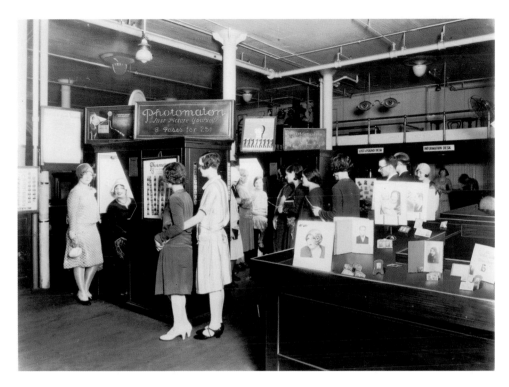

An original Photomaton studio, 1927.

This slight, handsome, vivacious inventor constantly won people over with his enthusiasm and brilliance. By September 1925 he had opened up his Photomaton Studio in New York City on Broadway, between Fifty-first and Fifty-second Streets. Crowds, as many as 7,500 people a day, were lining up to have their photos taken for 25 cents for a strip of eight different photos. "The place came to be known as Broadway's greatest quarter-snatcher." The New York governor and a senator were among those waiting for the fun of the automatic photo strip. A white-gloved attendant would guide people to the booth and, once inside, direct them to "look to the right, look to the left, look at the camera."

Anatol had achieved the American Dream. He romanced a beautiful silent film acress named Ganna, and he was making plans for the future, when he was contacted by Henry Morganthau, the former American ambassador to Turkey and one of the founders of the American Red Cross.

Morganthau put together a board of directors with authority to make an offer to Josepho to buy both his photo machines and the Photomaton patent. Among those on the board were James G. Harbord, president of RCA, John T. Underwood, president of the Underwood Typewriter Corporation, Raymond B. Small, president of Photomaton, Inc., and also the former vice president of Postum Cereals, and

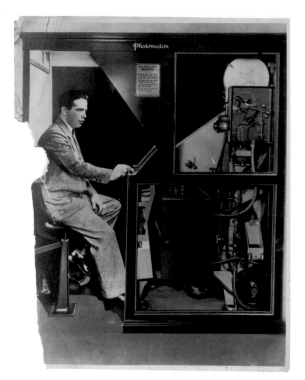

The original Anatol Josepho publicity photo, 1925.

Henry Morganthau Jr. (who would later reach great fame as the secretary of the treasury under Franklin D. Roosevelt). The other five members were also men of great wealth and influence.

It was 1926 and an offer was made. One million dollars for the American rights! March 28, 1927, on the front page of the *New York Times*, top and center, the headline read: "Slot Photo Device Brings $1,000,000 to Young Inventor." Morganthau Sr. was quoted as saying, "We will open a studio at Atlantic City in a few days. In the week thereafter, we will open one at Coney Island. Then we will begin to dot strategic points in this country with studios at a rate slightly more rapid than one a week. At the end of this year, we will have seventy more studios in operation. Next we plan to establish one hundred fifty more." He goes on to say, "I believe that through Mr. Josepho's invention, we can make personal photography easily and cheaply available to the masses of this country. We propose to do in the photographic field what Woolworth's has accomplished in novelties and merchandise, Ford in automobiles and the chain store in supplying the necessities and luxuries of life over widespread areas."

Anatol accepted the million dollars. He immediately gave part of the money away to the needy of New York City. The press reacted negatively. Because of the revolution, his Russian origins, and the fact that he planned to give away much of his money, he was misinterpreted as a socialist. Journalists could not imagine anyone giving away this kind of money without a political agenda.

In the same article, Josepho was quoted as saying,

> I plan to create a trust fund of half of the first million dollars, to be devoted to general charity, based along economically sound lines. The other half million I plan to administer actively in the interest of various inventions that I consider worthy of development. The average inventor, as a rule, has a hard life. Moreover, it is rare for him to reap the rewards from his inventions as I have done. I shall certainly dedicate much of my life, and this newly achieved wealth, to helping my brother inventors to similar success.

Anatol and Gemma Josepho, 1940s.

You can imagine how many thousands of letters and requests for money Anatol must have received after his intention was published. When Anatol saw the

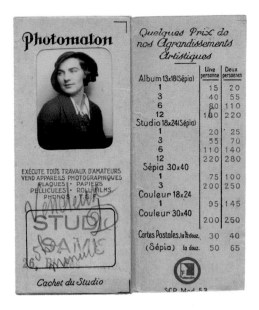

International Photomaton photos and enclosure listing the photo studios around the world (front and back).

announcement of the million-dollar check in the paper, he must have had mixed feelings, for there in the newspaper, in the very next column, was an even bigger headline stating that all foreigners were rapidly being evacuated out of Shanghai by American, British, and Japanese troops, to protect their nationals against "animus against foreigners." Anatol must have had a shudder or two, thinking about friends in Shanghai, and also how different his life might have been had he not emigrated earlier.

Very soon after receiving his money, Anatol married Ganna, the lovely and tiny silent film actress. After a European honeymoon they spent their time sorting through the thousands of letters requesting money. Anatol actually responded to those people who touched him. "Money is nothing, absolutely nothing, if it can't help those who need help. I don't need it now, but others who are going through what I have, do need it, so I am helping them."

The next year, Josepho sold the European rights for the Photomaton to an English/French consortium and the Photomaton started a journey that took the bulky and heavy booth to every country on earth.

While Anatol and his bride were planning a move back to California, the Photomaton creation was attracting attention in the commercial world. Within one year someone had applied for a patent with an improvement on the Photomaton. Efforts were also under way to update the automatic tintype machine, a poor competitor to the Photomaton.

At 1659 Broadway the crowds were still lining up. It was 1927 and New York

23

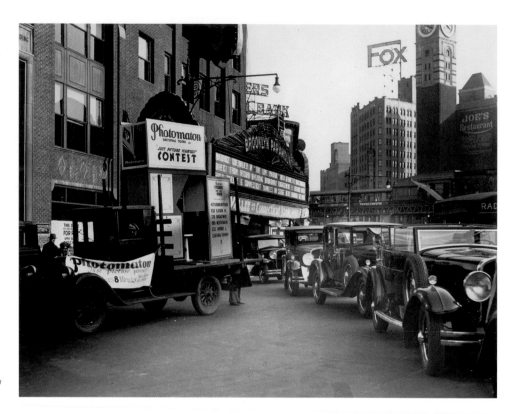

Traveling truck advertising six Photomaton studios in the New York City area, 1929.

City was the center of the world. At 1671 Broadway, just a few steps away, so-called Photomovette moved into a storefront with its photographic machines. The Photomovette motto was "Pose Yourself." They offered four-, six-, or eight-photo strips completed in five to ten minutes, and like Photomaton, enlargement, hand coloring, and photos on mirrors were also offered. Within a year, Photomaton was in court suing Photomovette for stealing its process and motto.

WHAT WAS THE BOOTH LIKE?

How did customers use this booth? In the first few years of their commercial use, photobooths were run by attendants. The sitter would give a quarter to the attendant to deposit in a coin slot and then the attendant would describe to the client how and where to look. The booth was illuminated by four lightbulbs (400 watts) and there was a white background to reflect light. After a wait of eight minutes, during which time no other photographs could be taken, a strip of eight black-and-white photos would emerge from an outside chute at the back of the booth. The strip was usually cut into eight separate photos and then inserted into an envelope

OPPOSITE: Photomovette advertisement, late 1920s.

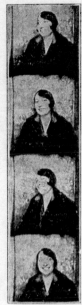
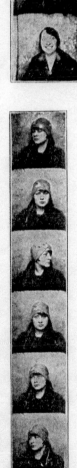

PHOTOMOVETTE
POSE YOURSELF

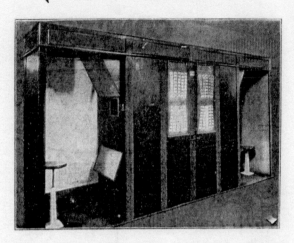

PHOTOGRAPHIC MACHINES

Strips of pictures taken automatically by inserting quarter in slot and finished manually in machine; four, six or eight photos to a strip.

This machine reduces overhead and labor costs to a minimum.

No expert mechanics needed.

The pictures are completed in five to ten minutes, depending on the rush of customers.

Suitable for installation at

AMUSEMENT RESORTS DEPARTMENT STORES
CARNIVALS FAIRS
AND ALL PLACES THAT DRAW A CROWD

MACHINES ARE PORTABLE AND DO NOT REQUIRE REFRIGERATION PLANTS.

They can be moved to fit your needs. Photomovette Machines are built in handsome cabinets 5 ft. wide by 14 ft. long, which contain the cameras, posing spaces, finishing and delivering apparatus. Each cabinet contains two machines and two posing spaces (one at each end).

Photomovette Machines make actual photographs, NOT REVERSED, which can be used for legal identification purposes, such as passports, chauffeurs' licenses, pistol permits, etc.

Additional money can be earned by enlargements made on these machines, by coloring, by putting pictures on mirrors and by sale of photo holders.

THE GREATEST MONEY MAKER OF THE AGE!

For all information as to State and city rights or for single cabinets apply

PHOTOMOVETTE, Inc.
1671 Broadway, **New York, N. Y.**

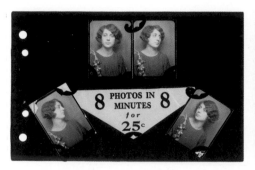
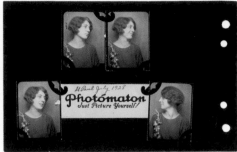

Typical pages from a photobooth album, St. Paul, Minnesota, 1928.

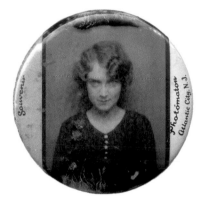

Photobooth mirror from a New Jersey studio.

featuring Photomaton advertising. Attendants urged customers to pick their favorite photos and have them enlarged and tinted at the local Photomaton studio.

In the late 1920s and '30s, studios varied from tented areas on the Jersey shore to elegant marbled rooms in New York City and Hollywood. The story of Anatol's success was well known to the average newspaper and magazine reader. In many of the studios smiling down from the walls were framed posters of Anatol, sitting in his invention, encouraging customers to smile and dream of a million-dollar idea coming into their lives.

What made the Photomaton booth different from the standard Kodak camera? To begin with, in the booth there was a sixteen-pound conventional camera in a large metal box with a very sharp lens. Instead of film, Anatol Josepho invented a new chemical process for producing a positive image directly on pretreated paper. In the beginning of photography, positive images were made on daguerreotypes, tintypes, and ambrotypes, using a variety of chemicals and silver. Street cameras also produced a fair-quality positive image on postcards. Josepho invented a better way of producing a sharp, distinctive photo on paper without a negative. To develop this "positive paper," the paper would be mechanically moved into different chambers, which contained a developing solution, water, a bleaching solution, fixer, and then a toning solution. After a final washing with water, the eight-framed photo strip would be automatically "squeegeed" and then mechanically inserted into a dryer. As the strip slid out of the back of the machine, a pilot light would come on in the front to let people know the Photomaton was ready for the next sitter.

The motor featured a transmission gearbox and was maintained separately by mechanics who were required to clean the motor thoroughly once a week. Other maintenance, such as changing chemicals, could be done by a trained local employee. In 1926 and 1927, Anatol used Vaseline, as well as oil, to maintain the mechanicals.

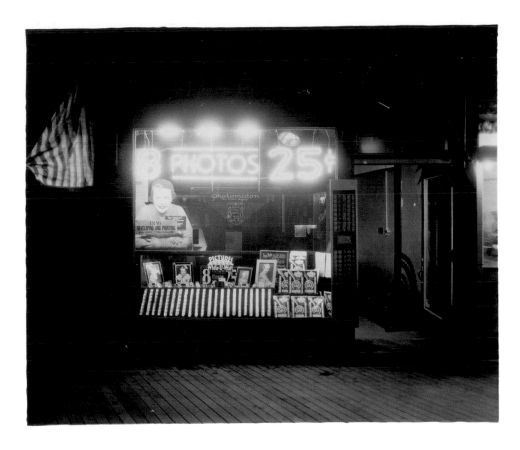

Photomaton studio storefront, 1920s.

THE PHOTOMATON AFTER ANATOL

In the late 1920s, Morganthau established a Photomaton factory, which was housed in a building at 3020 Thompson Avenue, Long Island City, New York. (This site today is the DeVry Institute of Technology.) Offices were originally located at 654 Madison Avenue in Manhattan.

In addition to assembly lines, packing areas, machine shops, and drafting rooms, there were four negative-making rooms (for enlargements), a printing room with capacity for six large projection printers, and three contact printers. There was another building where artists would tint images, a chemical lab for research, and an instruction school to train men in the care and operation of the Photomaton. The large Photomaton, later called the photobooth, was made of walnut. There were 3,095 different parts in the interior machinery. "Colonel" Robert C. Davis originally ran the company. His three-year commitment was to place photobooths all across America. Photomaton owners and employees considered themselves photographers and the shops, or booth spaces, were called studios. Attendants wore smocks and, sometimes, white gloves to direct the attention

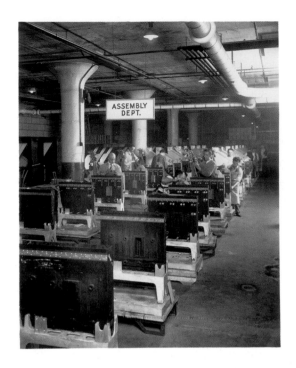

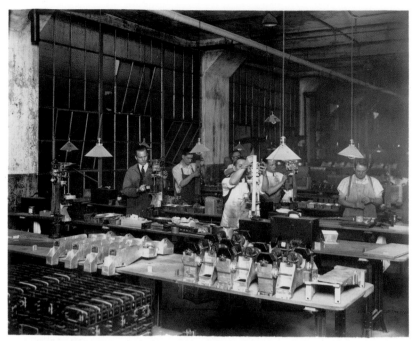

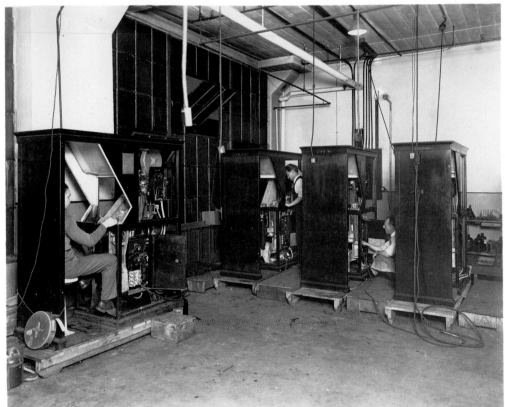

ABOVE, LEFT: Assembly line
Photomaton factory, 1926-32.

ABOVE, RIGHT: Assembly line of
photo paper conveyors.

RIGHT: Final installation of
photobooths. Note the paper
reel in left bottom corner.

of the sitter. Attendants were also constantly encouraged to sell, promote, and create a professional atmosphere that made people want to return frequently.

Engineers and design people maintained working communication with the British Photomaton company (which was separately owned). Later, the American Photomaton company started buying some of the older booths from the English and refurbishing them to sell in the States. Working with the Eastman Kodak Company, and later the Positype Corporation, the positive paper was still produced to Josepho's specifications.

In 1929, memos from American Photomaton were sent out to all the studios that Josepho's new camera, the Maton, would soon be produced and that stores would carry the chemistry for the camera. The Maton camera used the same size positive paper as the photobooth (requiring no negative) and could be developed on the spot. But the camera never caused the sensation that was expected. Sales were minor in France, where the camera was manufactured, and the camera was not promoted with much enthusiasm in the United States. In Germany another, more sophisticated version of this camera was produced. It was called the "night camera," or Goerz Matonox Nacht Kamera. It used the Photomaton lens (1926).

In 1927, a young inventor named John Anton Slack started work as the assistant production factory manager at the Photomaton Company. Slack was born in 1896, and like so many others in his generation he had to drop out of high school to support his mother, brother, and sisters. Starting work at age fifteen in machine shops, John spent his spare time at the New York Public Library learning as much as he could about science, chemistry, and electronics. Slack next got a job working at the new Photomaton

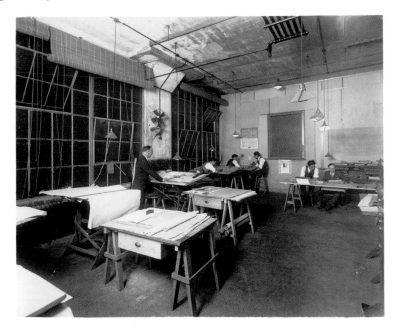

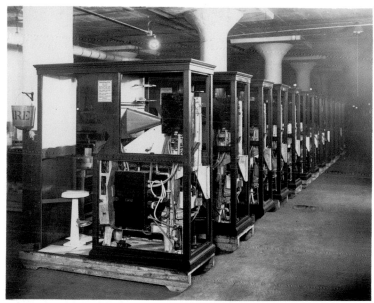

TOP: Original Photomaton factory in New York. John Slack is standing at drafting table in foreground, early 1930s.

BOTTOM: First Photomatons prior to finished assembly, 1926.

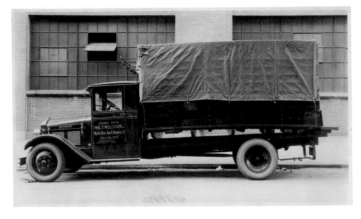

Delivery truck loaded with Photomaton booths, 1928.

The Photomatic Corporation of America was founded in Cleveland in 1935 by a dentist, Dr. Joseph E. Klein. Using Josepho's chemistry and a delivery system like David McCowan's, it was on the market for only a relatively short time. The woman in the photo is Lillian Uhl.

factory in Long Island City. As was the custom of many companies at the time, Slack was expected to give all the credit for his inventions to Photomaton. Slack began refining the paper delivery systems and prisms in the camera. Outside of the company, people were applying for patents revising the existing photobooths.

One of the most significant inventions for which Slack was responsible was the creation of the "plumbless" machine. Prior to this invention, the Photomaton had to be connected to a water supply, which sprayed the paper strips between chemical immersions. If there was low water pressure the machine could not work. Also, cleaning calcium off the spray heads created more work. Slack and one of the Photomaton engineers designed a system of self-contained water immersion tanks for washing the strips.

In 1929, John Slack also created a booth that took a black silhouette, instead of the regular photo, for 50 cents. He had hopes, also, of offering a variety of backdrops, a lens technique to create more intimate close-ups, and fun props. These innovations were vetoed by the company president. The silhouette photobooth was discontinued and this was the beginning of Slack's disillusionment with the company.

Slack was still so highly regarded that the company sent him to Cleveland and other midwestern towns to tinker, refine, and help the franchise Photomaton studios to succeed. As Morganthau had predicted, studios had lines around the block and were opening all over America (even in Hawaii). The motto of the company, "Just Picture Yourself," was picturing hefty profits for owners and stockholders. At the height of the Depression, people could still find a dime or a quarter to take what, for some, was probably the only photograph they could afford.

By 1928 one of the owners of a photobooth studio in Atlantic City claimed that his combined booths had taken over half a million strips in eighteen months. By 1929 there were more than fifty successfully operating Photomaton studios in the country. Though many studios did their own enlargements and color tinting, there were thousands of enlargements per month being sent to the Long Island City factory for processing.

While Slack was putting in long hours working at the factory, he eventually rose to the position of assistant to the president. By 1933 Slack had invented a method for speeding up the development time of photos. He designed a better

temperature control. He created a reflective mirror for the booth, so that people could see themselves pose, yet the glass would still permit the camera to focus. He was also working with an idea to create a camera, possibly to be used in the booth, that required no chemicals and a minimal amount of light by using a photoelectric cell or other electrical current. This was eighty years prior to the digital camera. The idea was never patented.

In 1932, after many arguments with the management over loss of his patent rights, Slack left what was now the New Photomaton Company. He did not leave alone. In the process of divorcing his first wife, Slack had convinced the beautiful executive secretary to the president of the company to marry him and to set up their own Photomaton store.

Slack and Lillian Uhl rented a space at 1575 Broadway in Manhattan and bought photobooth equipment and supplies from the American Portraiture Corporation, which had been maintaining a photobooth studio in the same spot. After a couple of years, the business was renamed Automatic Enterprises. After John's divorce proceedings, Lillian's savings financed the operation. Like so many businesses in the 1930s, all their relatives worked for them and were grateful for employment. Located next to the Strand Theatre, people could see a movie and take their photos afterward. In the Edward Hopper painting *Chop Suey*, two flappers are seen eating at a table across from the Strand Theatre, but Hopper left the Photomaton store out of the painting.

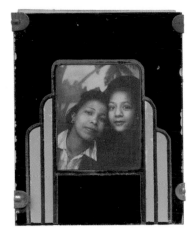

An art deco glass frame sold at photobooth outlets, 1930s.

Times Square, New York City, location of John Slack's Photomaton store.

31

In addition to enlargements and tinting, Photomaton studios also offered to place photos on the back of vanity mirrors.

The Broadway Photomaton studio that operated in Times Square, New York, in 1944 was open from noon until four in the morning. Large crowds of service people, out on leave, celebrated their free time in the heart of New York. In this busy spot, twenty-one employees, working different shifts, not only directed clients to the machine but also tried to talk them into enlargements, colored photographs, special mountings, and other novelties. These extras were a large part of the store's income. Both men and women worked as salespeople, but New York law forbade women to work after ten p.m., so the men comprised a larger part of the sales force. Pay for everyone was 60 cents per hour, plus two percent commission on photobooth strips sold and three percent commission on extras, such as enlargements. More than 50 percent of the store's income was earned after nine p.m. The average employee of a photobooth store in 1944 earned $37 per week, close to the average salary in that year.

The 1930s and '40s were good to the Photomaton store. With just four booths, the shop was able to support John and Lillian, their children, and the seven or eight relatives who now worked there. Slack bought a large home on Long Island, but continued to work long hours. With the advent of the Second World War,

Outside John Slack's Times Square Photomaton studio, 1930s.

John Slack outside his Times Square store, 1950s.

Popular glass frame designed for photobooths, 1940s.

soldiers and sailors lined up outside every night until three or four in the morning. But even with all those quarters cascading into the till, all was not paradise. The photobooth factory had been shut down to produce machinery for the war effort. Finding photo paper was a scramble. The air force was commandeering most photopositive paper for war use. All photobooth owners were in competition to find the limited paper available. By 1942 Kodak was producing only 50 percent of its film for the public. Yet until the war ended, Slack's store in midtown Manhattan remained a pot of gold. After the war ended, the store's income dropped radically and Slack was forced to sell radios, voice-recording booth space, and other early electronics to replace the loss of income from service people no longer coming in.

With rents going up, John was pressured, in the 1950s, to give up his lease, move to a smaller home, and reevaluate his life. He had unsuccessfully sued to get his invention rights back. Remaining a cheerful, outgoing man, he spent the rest of his life as a television salesman, until he died in his seventies. But he never was quite able to give up the photobooth dream. Until the end of his life, he kept the old Photomatons in his garage and had them regularly serviced and run, with what hope we will never know. Slack's son, Jeffrey, remembers running off with long reels of photobooth developing paper and spooling them out in the backyard

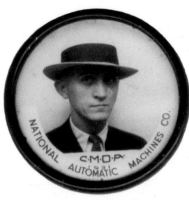

Phototeria disc with image of inventor David McCowan. Includes "drying" envelope. Courtesy of the McCowan family.

to make tracks for his miniature racing cars. Like streamers of celebration, he would watch the long white strips darken in the sun.

PHOTOTERIA

In the early 1920s while Anatol Josepho was getting ready to leave Shanghai for the American west coast and, ultimately, the long hitchhike to New York City, another mechanical inventor, David McCowan, was growing up on a Canadian farm in Scarborough, Ontario. David had a nearly crippling stammer and, after four days in a one-room school, declared he would not go back. With an aunt home schooling him, David spent most of his time alone building toy railroads that ran in the back of the house. As he developed into his late teens, he started a business making toy tin mice and airplanes and selling them to Woolworth's. A young Canadian tycoon was born.

By age twenty David had declared himself David A. McCowan Manufacturing.

After setting up his toy company, and manufacturing soccer and baseball coin-operated games, the business evolved into producing wireless radio components and folding display racks. On one of his many business trips to New York City, McCowan saw Josepho's Photomaton. The mechanics of vending machines had always interested him and here was a perfect marriage of the coin-op machine and automatic photos that proved a provocative combination.

It was 1926 and David McCowan could barely wait for the train to Toronto and to his machine shop on Main Street. He immediately started tackling the problem of how to create his own photobooth with a novel style of photography, something very marketable and Canadian. McCowan had no experience with photography beyond taking family photos with his Kodak. A smart man, he consulted with a lens manufacturer, Wollensak U.S.A., explaining that he wanted a lens that could provide close-ups at a very short range that would be flattering. Next he had to figure out how Josepho had produced his photos and how he could come up with something that was faster and looked distinctly different. Knowing nothing about photochemistry, he talked to dozens of photographers about his ideas and they all told him it was impossible. But "impossible" was only a challenge to this northern Canadian.

McCowan spent weeks reading everything he could in the library about photo chemistry and earlier forms of automatic photo machines. In the interim, McCowan had the men in his shop—and, remember, he was only twenty-seven

years old at this time—work on manufacturing the parts for the machine from his own blueprints. His photobooth would be called the Phototeria.

After fifteen months, McCowan had completed his project and he speculated that the first Phototeria cost him around $25,000 (equivalent today to $268,000). The booth was much smaller than the Photomaton. Constructed with beautiful mahogany, it was seventy-three inches high, only forty-eight inches long, and an amazingly slim twenty-six inches wide. The cast aluminum seat was 20 inches high inside the booth, which was raised on a three-inch wooden platform. On both sides of the booth were sliding wooden doors (with interior mirrors) so that the sitter could have total privacy.

When you stepped into the booth lights automatically went on. After a quarter was inserted there were two options: either a hand crank could be turned to start the process or the person would just wait for the machine to begin. McCowan had designed a little fluttering toy bird that, like a cuckoo clock, would come out of its door, after the insertion of the coin, focusing the sitter's attention for the eight seconds that the person had to sit still, and then return to its mechanical nest. In only half a minute, at the back of the machine, a disc measuring two and a quarter inches would be delivered. On one side would be a black-and-white head shot of the sitter and on the other a vanity mirror.

In late 1927, McCowan started placing his booths in small Ontario towns as a test to see if people would use them. As he told friends later on, after one or two tests he came home with bags of quarters and, with his father, McCowan Senior, sitting there, he would cover the kitchen table with $500 in quarters. His father, who later became a member of the Ontario legislature, would chuckle at the yield from one day's work compared to the much leaner days on the farm.

Young McCowan was feeling on top of the world. He had conquered his stammering by teaching himself a new breathing method and learning to talk all over again without swallowing his words. He was manufacturing Phototerias that were being placed from Ontario and Regina and Saskatoon to Vancouver and Victoria, British Columbia. In addition to money coming in from the machines, McCowan was thinking ahead to selling the patent for the Phototeria and supplying the machines with the photo disc for which he also had a patent.

Original metal plate from the interior of McCowan's Phototeria. Very similar to the Photomaton plate.

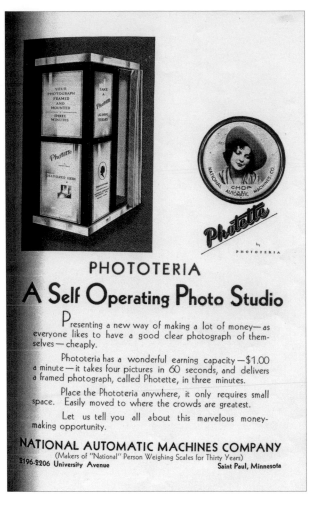

PHOTOTERIA

A Self Operating Photo Studio

Presenting a new way of making a lot of money— as everyone likes to have a good clear photograph of themselves — cheaply.

Phototeria has a wonderful earning capacity — $1.00 a minute — it takes four pictures in 60 seconds, and delivers a framed photograph, called Photette, in three minutes.

Place the Phototeria anywhere, it only requires small space. Easily moved to where the crowds are greatest.

Let us tell you all about this marvelous money-making opportunity.

NATIONAL AUTOMATIC MACHINES COMPANY
(Makers of "National" Person Weighing Scales for Thirty Years)
2196-2206 University Avenue Saint Paul, Minnesota

Phototeria ad, 1931. The external cabinet is almost identical to contempory design.

Every year in Chicago and other major American cities, since the invention of the coin-operated machines, trade shows and conventions were held in hotels. David McCowan decided in 1928 to crate up his Phototeria, drive it through the border, and present it in Chicago. His hope was perhaps to sell it for 2 million dollars, like Josepho had sold his Photomaton. And he had good reason to believe it would happen. A group of Canadian businessmen had offered him $210,000 to buy the Canadian rights. Another client was flying up from Rio de Janeiro to discuss marketing the Phototeria in Brazil. McCowan started planning and thinking about how he would market the machine worldwide and be in charge of manufacturing the photodiscs and chemistry for the Phototeria.

Chicago would be the first step on this world stage. Standing by his machine at the Chicago convention encouraging enthusiastic businesspeople to have their photos taken and perhaps buy the machine, McCowan was approached by two tough but well-dressed men. Asked to leave the convention hotel in a manner he could not refuse the two men accompanied him to see "an interested party" in another private hotel room. The elevator was taken, the door was opened, and there, in an elegant suite, smoking his cigar, was Al Capone. In 1928, Capone was at the height of his criminal career. It was the year before the Saint Valentine's Day massacre, but both Americans and Canadians knew that Mr. Capone was no one to get into an argument with. Both Capone and McCowan were twenty-nine years old. One ruled an empire, the other was aspiring to. Capone, polite, gracious, and with no introduction, just looked at McCowan and said, simply, "We run all the vending in this country." Simple. Complete. McCowan left the room, shaken. The next day the booth was crated and David McCowan was on the road back to his family and the less traumatic Toronto.

Continuing to make good money with the Phototeria, and with its sale imminent in Canada, McCowan met with a manufacturing company from Saint Paul, Minnesota. The National Automatic Machines Company, which had made vend-

ing weight scales for thirty years, decided to buy the American patent for the Phototeria. The Phototeria was redesigned and called the Photette. This 1930 model looked, remarkably, almost exactly like the Photo-Me booth, available in 2005. It was streamlined, curtains replaced sliding doors, and metal replaced wood. It was capable of producing four photo discs in a minute. According to an article in *Automatic Age*, June 1931, at the Coin Machine Operators Convention at the Hotel Winton, in Cleveland, "Over three thousand photographs were snapped at the Cleveland convention and over two thousand five hundred at the Vending Machine Manufacturers Convention at the Hotel New Yorker in New York City. Every picture pleased its subject."

McCowan was pleased as he pocketed his money and moved on to other ventures. A couple of years later he was off to Alberta, where he rented land and equipment and tried to get involved in coal mining. After investing most of the photo money in this misadventure, he returned to his family in Toronto and continued to design and apply for ten more patents on display racks, designs for advertising, and floating barges. His manufacturing company proved to be very successful and he worked with Cadbury Chocolate and Esso. Restless and curious, McCowan told his son, Peter, that he always got his best ideas in church during the long, dry sermons.

With the last two Phototerias stored in his barn, McCowan retired in his late sixties and spent the last years of his life racing his Rolls-Royce around the farm, in the mud, through the fields, to fix fences and carry equipment. Every Sunday the car would be washed and driven to church. He passed away in the early 1980s and, just like Josepho, he left a life well lived and a legacy of possibility for anyone with a dream.

McCowan and Josepho also generated a long list of competitors who copied (sometimes not legally) the machines and chemical processes. Patent suits were in and out of court constantly. Here is a small list of some of the other photobooths

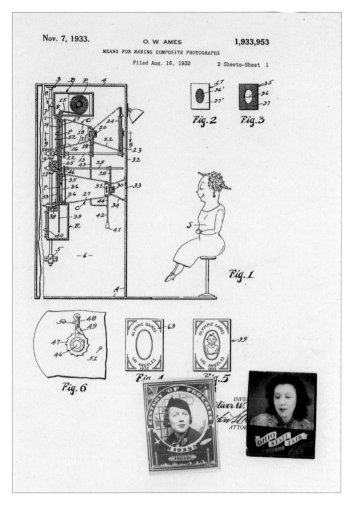

Patent application for "masked" photos in a machine, 1933.

French Photo-Weigh portrait, 1932.

that came on the market in the United States in 1931: Auto-Photo-Dome (automatic photos on disc for a dime) from New York City; Roovers Brothers Incorporated of Brooklyn (five-inch strip of five photos for 10 cents); Quartermatic Photo Machine, made in Rochester, New York (eight pictures for 25 cents), printed with sepia tone; Photo-Weigh Machine, German product with an American sales office in New York City (ten cents for your photo and your weight, and for 25 cents more, a companion machine would give you an enlargement); Movie-of-You by Mr. A. H. Woods of New York (vari-colored moving picture); Tru-Photo Machine made by the Rapid Vending Corporation; American Phototure Company of Dover, Delaware; Automatic Film Machine Corporation of Wilmington, Delaware; the Photola (made in 1931, photos cost 10 cents); Photosnap, Inc. (photos for 10 cents).

These booths took millions of photos and in all different sizes. Most lasted only a few years. Where the old booths have all gone is a graveyard mystery. Except for the one 1928 Phototeria salvaged from the McCowan barn at this time the only other known vintage booths are from the early 1930s and are in the hands of three or four fanatic collectors. To identify which photo came from which style booth (except for the Photomaton, AutoPhoto, and Mutoscope's Photomatic) is almost impossible.

The Operation of the Phototeria

The Canadian patent for this lightweight, sophisticated novelty photobooth was taken out March 26, 1928. Reading the patent, you can see the fingerprints of Josepho's chemical process and the design of the GE Photo-Button machines.

Using the idea of Josepho's enclosed wooden booth as a starting point, McCowan greatly reduced the size of the cabinet. By producing photo discs, instead of complicated long strips, he was able to reduce machinery size to less than half of what went into a Photomaton.

The Phototeria was designed to be fun. The interior mechanical partition looked something like an amusement park for leprechauns. Full of reels, chutes, and water-misting pipes, the interior had a complicated beauty. The machine worked like this: after the customer dropped a coin or a photo token down a pay slot, the machine would switch on. In the top of the interior were six stacks of unexposed photo discs. One would slide down a chute and fall into place in a reel, which could accommodate twelve discs. Moving vertically, the unexposed photo paper disc would be exposed behind the lens, and then, as the reel rotated circularly, the disc would be discharged down another chute and fall into place

on a horizontal reel. The reel, rotating slowly, would pass under a valve from which developing fluid would be released. Another valve would blow vaporous warm water across the surface of the photo disc. Then another photo bath would be released by another valve in the wheel's rotation. There were four different baths in all. The used fluids would run down a drain groove to the bottom of the cabinet into a waste bin. There would be a final blast of hot air and then the disc would be thrust out of the reel down its final chute in the back of the machine and into the hands of the eager customer. The whole process took less than a minute and, after seventy-five years, the photos have not faded.

AUTOMATIC PHOTOGRAPHIC MACHINES

At this time in the story, it is important to look back and understand that the photobooth did not just suddenly appear. It was really the culmination of thirty years of attempts at creating a camera independent of a photographer. After years of semi-successful patent applications by photographers, inventors, and chemists trying to create a self-operated automatic booth, Anatol Josepho was the right man at the right time. Here is a description of the world he walked into.

Who would have thought that the 1894 invention of a Parisian vending machine to dispense gum would have changed the photo industry? That mechanical revolution in photography, photobooths and self-portraits, is still going on and constantly reinventing itself today in the digital age.

With the idea of a self-operated coin machine, the French tintypists immediately began building "automatic photo machines." In the United States, photographers started constructing their own mechanical versions. Like busy bees, there was constant cross-pollination in the photo machine industry.

In the 1890s and early 1900s, people sensed that machines were going to change their lives. The idea of a machine taking a photo was consistent in the age of Thomas Edison, Jules Verne, and Alexander Graham Bell. For the average person, though, the machine turned the formal photo studio experience into a fun, inexpensive adventure. It was as easy as carrying a dime in your pocket. The early tintype machines were also catching the eye of other American inventors. The idea of the automatic camera was tried in arenas other than that of the photobooth. Among these was the invention of an automatic photo machine for the house to photograph burglars. A burglar could trigger an electrical connection by stepping on a mat or opening a window. One minor problem was that the

Metal tokens issued for use in the Photomaton, Phototeria, Mutoscope's Photomatic, and other early booths.

RIGHT: Very rare 1900 paper folder for French tintype automatic photo machine.

BELOW: French automatic tintype, very different from the North American versions.

40

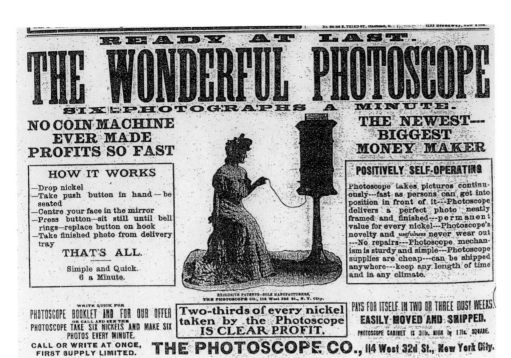

Early 1900s ad from the *New York Clipper* for an automatic photo machine.

magnesium powder flash, set off by the burglar, could also catch the house on fire. Other patents appeared for similar cameras to be set up in the woods to take night portraits of birds or animals. But the most popular and profitable automatic machines were the photobooth's precursors.

The best known of the tintype machines of the time were Ferrer's Photographic Automaton (1895, France); Matthew Steffen's Auto-Photo (1889, England); Automatic Photograph Machine (1895, United States); Photoscope (late 1890s, United States); Bosco Automaton (1890s, France); and the General Electric Coin-Op Photo Machine (1915, United States).

In Cleveland, Ohio, a major industrial center in the 1920s, the photographic designer and inventor George N. Piper was responsibile for a series of patents dealing with positive images on paper, camera machines that were semiautomatic, and corresponding chemistries. He joined forces with Leo Stern and they formed the Speedtype Operating Company. Called automatic, these machines still required an attendant. Stern in the 1920s and early '30s drove with an assistant throught the South, Texas, and California, setting up temporary

Brochure from the Speedtype Operating Company owned by Leo Stern (Cleveland). The company produced automatic photo machines, traveling photo studios, and later promoted Photomatons. The company existed from the mid-1920s till the mid-1940s.

SPEEDTYPE
PHOTOGRAPHY

SPEEDTYPE MACHINE is the Perfection and Culmination of many years' Experience by the Author and Pioneer in Instantaneous Processes. It is the last word for "Quick Delivery." Entirely automatic and turns out the Pictures in 30 seconds. Makes two Pictures with every Operation.

Has the Adaptability of Prices to suit every Location or Community. A price range of *10c, 15c, 25c,* or *One Dollar* Photography. Answers *Completely* the demand for *Mechanized Photography.* Squarely meets the Competition of the Chain Studio System: Competes with Cheap Photography by Superior Methods: No "Trinket" Photography to wear off, or laid aside — Straight Orthodox Portraiture.

SPEEDTYPE OPERATING COMPANY
1276 WEST 3RD STREET, MARION BUILDING
CLEVELAND, OHIO

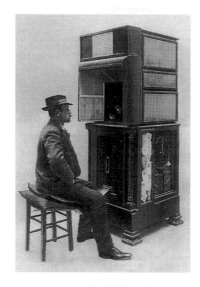

ABOVE: Early automatic photo machine putting portraits on postcards. Courtesy of Rodger Kingston.

RIGHT: Ad for an automatic machine camera, producing a photobooth-style photograph. George N. Piper, inventor.

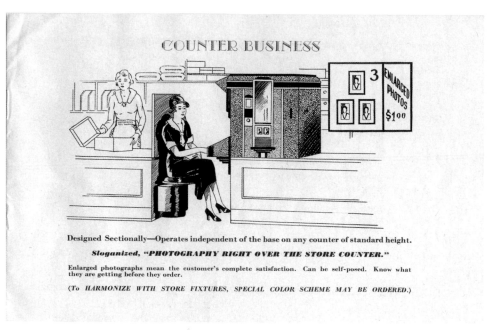

COUNTER BUSINESS

3 ENLARGED PHOTOS $1.00

Designed Sectionally—Operates independent of the base on any counter of standard height.

Sloganized, "PHOTOGRAPHY RIGHT OVER THE STORE COUNTER."

Enlarged photographs mean the customer's complete satisfaction. Can be self-posed. Know what they are getting before they order.

(To HARMONIZE WITH STORE FIXTURES, SPECIAL COLOR SCHEME MAY BE ORDERED.)

Automatic tintype from early 1900s. The machines required an assistant and daily maintenance.

"automatic" photobooth studios in storefronts and department stores. The photos were called "Hollywood gems." They were also smaller then the Photomaton images. Piper continued to design and patent his photography ideas for more than forty-five years. The Speedtype company disappeared after the Second World War.

Stern then opened up the Leo Stern Studios in Kansas City, Missouri. Becoming a talented photographer, he photographed the Truman family and his portrait of President Truman became a U.S. postage stamp.

In the same time period, 1895 through 1925, other photos that today are mistaken for early photobooth shots were actually done in multiple strips on portions

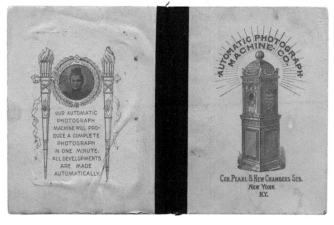

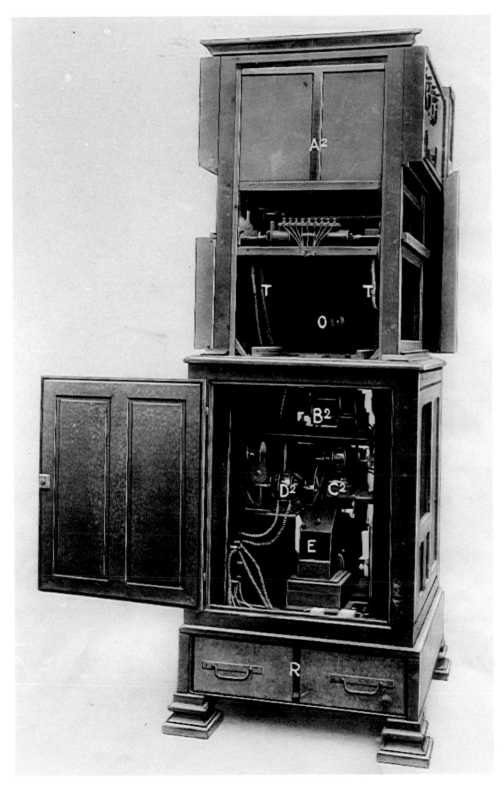

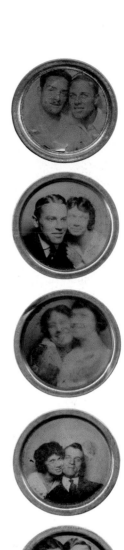

ABOVE: Tintype photos from General Electric and other automatic tintype machines.

LEFT: Interior of an early automatic photo-postcard machine. Courtesy of Rodger Kingston.

"Movie photo" taken in John Slack's photobooth. The sense of motion in the photo is achieved by three exposures on the same frame. This frame is placed under a lined sheet of acetate and, when moved, appears to show animation. The subject in the photo is Mr. Slack.

of a five-by-seven negative-plate Penny Camera. These photos had two popular names. Called "penny photos" or "ping pong photos," they were cheaply done and available in penny arcades or photo studios. Usually made in horizontal strips, they closely resemble photobooth strips. Josepho, in his studio in Shanghai, made a large part of his income from penny photos. They remained popular until the late 1920s when the easy accessibility of photobooths ended this style of photography.

ALTERNATIVE BOOTHS

In 1928, combining the early design of an English inventor and Josepho's Photomaton, Stanley J. Pask produced a photobooth image that "moved." Commercially available in 1930, this animated photobooth photo was created by exposing three pictures on the same frame of treated photo paper. The image is shot through a transparent screen that has opaque lines running through it. At each of the three exposures, the screen is automatically shifted and the person changes facial expression. After the three exposures, the "film" is automatically developed, supposedly in twelve seconds, and placed between two pieces of a cardboard mount. Over the photo is vertically lined clear acetate and, as the sides of the cardboard are pinched, the face moves. The commercial slogan promised to "let people see how they looked in moving pictures."

The image appeared briefly at one of the 1930 world's fairs and then reemerged in the late 1940s in John Slack's Photomaton store and other photobooth studios. Called "movie photos," a standard photobooth's interior machinery could be adjusted to take three exposures on the same frame. Lined acetate was put over the lens and the finished picture. The finished image was enclosed in a bright red mount. One would pull the photo strip up and down and the pictured face would change.

PHOTOBOOTHS IN THE THIRTIES

Photobooths all over the country, in the 1930s, had distinct styles and personalities. Some were made without prisms and therefore reversed images were not

corrected. As with the earlier daguerreotypes and tintypes, individuals started thinking about adding backdrops to make their photobooths unique. Whatever was available was used, including wallpaper, hand-drawn or painted murals, fabric, curtains, and venetian blinds. Cardboard cutouts were also used in front of the sitter, of a humorous body, or a valentine cutout.

Located near one state park in the California area was a booth that had a local forested scene painted in the backdrop. The owner added cowboy hats and bandannas for the sitters to reincarnate their inner cowboys. Like the older tintypes, state fair operators allowed customers to scribble their names and dates in the booth for that extra-special souvenir.

For the 1933 World's Fair in Chicago, individual special backdrops were designed. There is no evidence of backdrops being formally manufactured for photobooths. Because booths were set in public spaces, there may also have been concerns about theft or vandalism to backdrops. In the thirties and forties, photobooth pictures came in at least twenty different original sizes.

Licenses were sold from the original patent and very small photobooth factories started springing up in the Midwest. The Olson Sales Company in Des Moines, Iowa, in 1935, offered a booth called "four for a dime" photo machine at $125. If you knew a little carpentry, and had your own design in mind, they would sell you the camera and lenses for $60, with full instructions on how to build your own booth. People in carnivals and traveling fairs and small studios paid attention. Self-made booths that could be easily assembled and taken apart started appearing in rural areas.

Marks and Fuller offered photobooth images at one and a half by two inches called the Photo-Strips Junior. The corresponding booth was yours for a $140 check to Rochester, New York, an address close to the home of Eastman Kodak.

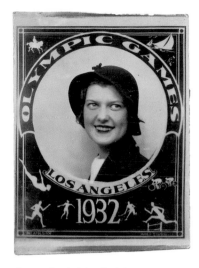

Composite photobooth picture from Olympic Games, Los Angeles, 1932.

BELOW, LEFT: Advertisement for construction of what appears to be a photobooth but is actually a faux booth with a small darkroom enclosed in the back, which slides photos down a chute to unsuspecting customers.

BELOW, RIGHT: Advertisement for full-length photobooth available by mail order, 1930s-1940s.

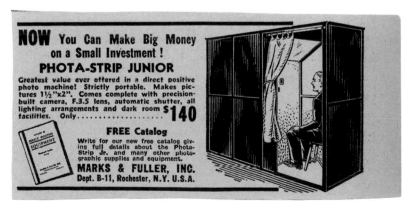

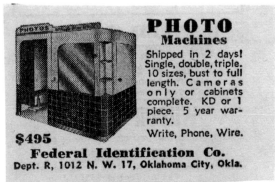

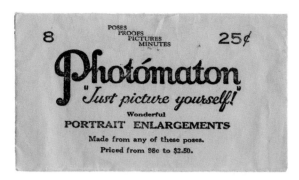

An example of a commercial envelope used by customers for storage of picures.

The photobooth machine offered by the Federal Identification Company in Oklahoma City was the most adventurous. The company offered photobooths in ten different original sizes, including a full room-size photobooth shot. These full-room shots could accommodate three large-sized adults from head to toe.

Anderson Camera Works in Kansas City offered a "four for ten cents" booth for $395 and guaranteed that its booth was portable and could be assembled in ten minutes.

Along with the booths a profitable cottage industry flourished. With a tiny darkroom, owners would enlarge images, tint them, and sell paper, metal, or glass frames and mailers.

The camera companies watching the photobooth revolution taking place were quick to make accommodations to their preexisting models. The Victor camera,

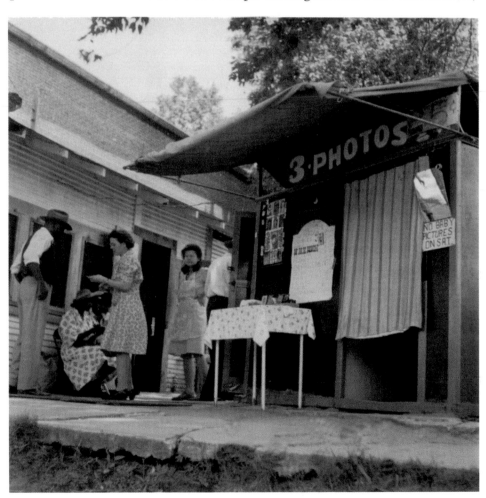

An anonymous photo of an itinerant homemade photobooth, late 1930s.

which had come of age in the late nineteenth century and had used glass negatives, was quickly converted for the use of Anatol's positive paper. Other street photographers, using the old luggage-like tintype box cameras (most of which were made by the Chicago Ferrotype Company), converted to boothlike paper positive images. The Daydark Specialty Company of St. Louis advertised, "Hundreds have been making big money with these cameras, even during the Depression!" Meanwhile, tintypes were gasping their last breaths, running ads right next to the photobooth ads and promoting their tintype buttons.

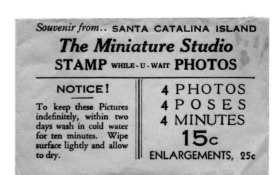

Cut photobooth pictures were given to customers in self-advertising envelopes.

A petite, doll-like camera was produced in New York City in the 1930s called the Photo-See Model 100. The two-piece camera was made of compressed paper and Bakelite, with a gorgeous art deco front piece. This attractive camera used direct positive paper as film that could be developed on the spot in one minute. Herman Casler, one of the founders of the American Mutoscope and Biograph Company, invented this camera. In 1894 he had invented the Mutoscope, a flip-card viewer. In competition with his onetime boss Thomas Edison, in 1896, Casler invented the Biograph projector for large-format 68/70 mm film. Like everyone else in the 1930s, Casler fell in love with the photobooth and saw its chemistry principle as something with greater potential. But the process was too complicated and messy for children for whom the camera was marketed. The Photo-See disappeared after a short time.

The P.D.Q. camera used the same paper film and chemistry as a photobooth.

Another camera directly descended from the Photomaton was the P.D.Q. camera. Introduced in the 1930s, this camera was very similar to Josepho's Maton camera. The photo paper and chemicals used were almost identical to those of the photobooth.

Somewhere in the Midwest, a manufacturer came up with the idea of building a booth space that would look like the Photomaton cabinet. Instead of having the expensive and complicated setup of the original machine, a P.D.Q. camera could be permanently installed in the booth and a man hidden in the front of the booth would quickly develop the paper and push the strip down the delivery chute. Couples cuddling for the photo would not realize they had a voyeur on the other side of the wall. According to David Haberstich,

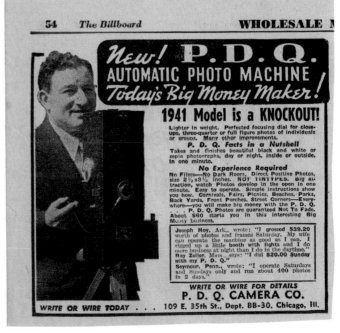

head of Photographic Collections for the Smithsonian, there were stories of people who sat in the booth, posed, thinking they were alone, having private photos taken, and then had the shock of their lives to witness a man exiting the back of the booth. At least five or six companies manufactured these faux booths, which could quickly be disassembled and moved from family picnics to county fairs.

THE BAILEY FAMILY

The story of the Minier/Bailey family is an American Wild West story. In the late 1920s, Ira Minier bought one of the very first Photomatons. A circus and fair photographer, he immediately saw its financial possibilities. In the early 1930s, using a brand-new trailer, he stripped away the heavy wooden booth, substituted a lightweight covering, and installed the photobooth in one end of the trailer. In another corner he probably curtained off a space to create a very small darkroom in order to make minimal enlargements. Using an outside tarp to fashion a small tented area, the family also sold horse and cowboy knickknacks.

The Minier family, Ira, Annie, and beautiful daughter, Carol, were originally from Illinois. On the circuit in Texas, and surviving quite well even with the depression in the flatlands, the jazzed-up photobooth was kept busy. Around 1933,

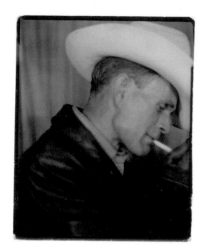

A photobooth of Al Bailey in the Bailey Photowagon. Courtesy of Andrew Allen Smith.

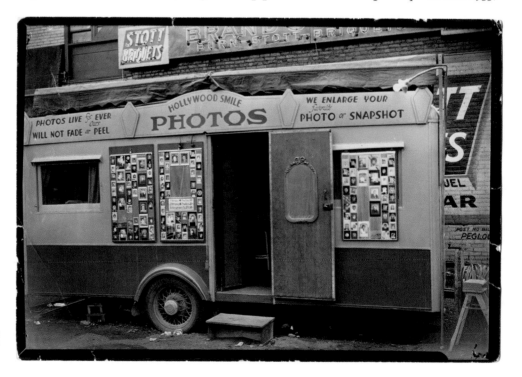

The Bailey Family's traveling photobooth wagon, early 1930s through the 1950s. Courtesy of Andrew Allen Smith.

48

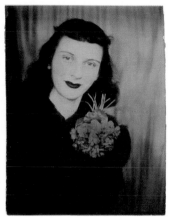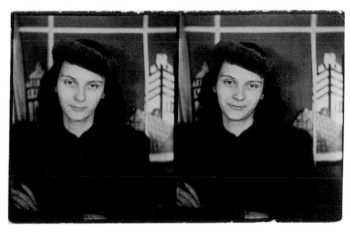

at one of the rodeo fairs, seventeen-year-old Carol Minier was alone and running the photobooth operation when in walked a lanky, striking forty-three-year-old rodeo star, and Carol's life forever changed. Directing Albert Bailey inside the booth to look to the right, then to the left, he looked at her and fell in love. A divorced, older man with a slight outlaw flair was too much temptation and Carol, ignoring her parents' conservative values, married her cowboy.

Al "Sequah" Bailey was a Texas cowboy with John Wayne–type charm. Al or "Hap" Bailey had grown up on his father's ranch in Texas. Around 1900 his mother and her new baby had gone east for a family visit. Al's mother and the baby disappeared and his father, distraught, spent the rest of his life and all his money looking for them. No trace was ever found.

After years of ranch working, Bailey had developed spectacular skills with the lasso and cattle whips and had set himself up as a western entertainer. Carol, who developed quite a skill at hand-tinting photobooth pictures, was now a newlywed and being trained to work the cattle ropes as well. A quick study, she was eventually able to lasso four horses running abreast and had the calm nerves to let Al split a cigarette in her mouth with a twelve-foot cattle whip.

The Miniers now merged with the Baileys and the two rodeo entertainers with the photo trailer in tow began a new circus circuit, including Oklahoma, Iowa, the West, and Canada.

Not long after, in 1938, a beautiful child joined the Bailey family and Cody, named after Buffalo Bill, was incorporated as a toddler into their Wild West show. Traveling now with six people, including a nanny, the booth afforded the family not only a stable income but also an amazing record of the relationships among these people.

Self-tinted photos by Carol Bailey in her parents' photobooth wagon.

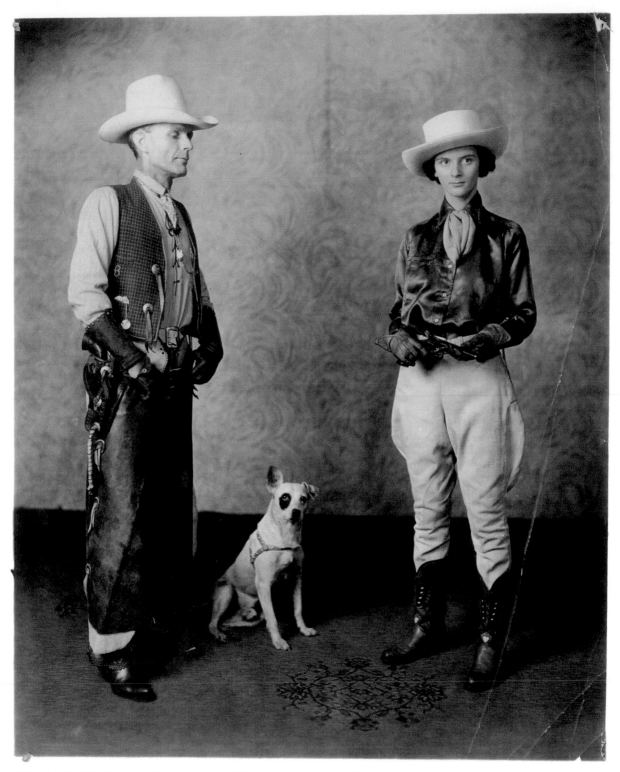

Carol, Al, and their buddy dressed for their rodeo act, 1930s. Courtesy of the Bailey-Zibman family.

Mr. Minier, using both curtains and painted backdrops, tried some nontraditional photobooth shots, including a series of tasteful, conservative nudes. Until the forties, this early photobooth in its own carriage traveled more than the majority of people did in this country. By the mid-decade, though, everything fell apart. With the Second World War, photo supplies were drying up. Gasoline was being rationed. Mrs. Minier started selling jewelry next to the trailer. Cody Bailey, who had been home-schooled, left the rodeo life behind and joined the marines. The stress was too much and the Bailey marriage floundered.

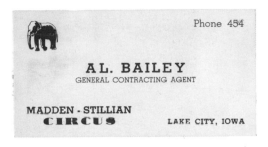

Al Bailey's card from one of the many ventures he and Carol were involved with. Courtesy of the Bailey-Zibman family.

Carol and the photobooth ended up in the Princeton, Illinois, area. Remarried to Leo Chabot, the theatrical Carol still had yearnings for the road. The photobooth trailer was stripped down and spent its last working days on the outskirts of a long traveled career.

After the breakup, Al continued his career by running and performing in another Wild West show. But times had changed. With the competition of TV and movies, the crowds were never the same. Al Bailey, who was less than a day's drive from Carol, remained her close friend. Every spring, Carol would tell her family that the call to go out and work with the old photobooth wagon was hard to resist. Cody came back into his father's life in 1961. Bringing his new wife, they met his father just before he was to go on stage at a charity benefit. It was his last working cowboy performance. Bailey collapsed onstage and died. He was seventy-one.

Carol lived until 1995. She died in the town in Illinois where she was born. That had been her wish. Where the Photomaton and the trailer ended is anybody's guess. It is not entirely impossible that somewhere in Illinois, perhaps in a forgotten barn, in a corner under some hay, it sits waiting for one more run.

MUTOSCOPE'S PHOTOMATIC

In 1934 a new photobooth appeared on the market that would revolutionize the business. The International Mutoscope Reel Company of New York produced a scaled-down, futuristic, art deco booth that was just beautiful to look at. This booth was half the size of the Photomaton. Smaller and narrower, it could be placed with much more adaptability.

William Rabkin, who became president of International Mutoscope and Reel, bought a company that had its 1895 origin in Canastota, New York, founded by a machinist named Herman Casler and William Dickson, who had earlier worked

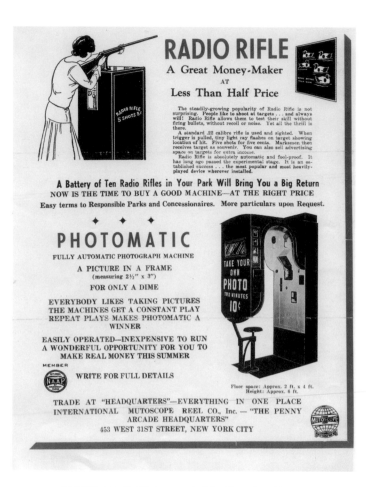

RADIO RIFLE
A Great Money-Maker
AT
Less Than Half Price

The steadily-growing popularity of Radio Rifle is not surprising. People like to shoot at targets . . . and always will! Radio Rifle allows them to test their skill without firing bullets, without recoil or noise. Yet all the thrill is there.

A standard .22 calibre rifle is used and sighted. When trigger is pulled, tiny light ray flashes on target showing location of hit. Five shots for five cents. Marksmen then receives target as souvenir. You can also sell advertising space on targets for extra income.

Radio Rifle is absolutely automatic and fool-proof. It has long ago passed the experimental stage. It is an established success . . . the most popular and most heavily-played device wherever installed.

A Battery of Ten Radio Rifles in Your Park Will Bring You a Big Return
NOW IS THE TIME TO BUY A GOOD MACHINE—AT THE RIGHT PRICE
Easy terms to Responsible Parks and Concessionaires. More particulars upon Request.

♦ ♦ ♦
PHOTOMATIC
FULLY AUTOMATIC PHOTOGRAPH MACHINE

A PICTURE IN A FRAME
(measuring 2½" x 3")
FOR ONLY A DIME

EVERYBODY LIKES TAKING PICTURES
THE MACHINES GET A CONSTANT PLAY
REPEAT PLAYS MAKES PHOTOMATIC A WINNER

EASILY OPERATED—INEXPENSIVE TO RUN
A WONDERFUL OPPORTUNITY FOR YOU TO MAKE REAL MONEY THIS SUMMER

MEMBER NAAP WRITE FOR FULL DETAILS

Floor space: Approx. 2 ft. x 4 ft.
Height: Approx. 6 ft.

TRADE AT "HEADQUARTERS"—EVERYTHING IN ONE PLACE
INTERNATIONAL MUTOSCOPE REEL CO., Inc. — "THE PENNY ARCADE HEADQUARTERS"
453 WEST 31ST STREET, NEW YORK CITY

Ad for the very first Mutoscope photobooth produced by William Rabkin.

with Thomas Edison to invent the Kinetograph, one of the first motion picture cameras. Dickson invented a better motion picture film, but Edison refused to let him have access to his camera. So Dickson and Casler had to invent a new camera, the Mutograph, and a viewer, the Mutoscope, to see the films. The two men renamed their company the American Mutoscope Company and put Edison's Kinetograph out of business. Heady with success, and with hundreds of their Mutoscope films in stock, the two men bought the Biograph (a moving picture projector) and the company became the American Mutoscope and Biograph Company. As Biograph movies produced hits with Mary Pickford and D. W. Griffith, the older Mutoscopes that were in penny arcades just kept recycling the same short films. By 1920 the company was in bad shape and Rabkin stepped in.

William Rabkin, the eldest of twelve children, was born in 1890 in Bobruisk, near Minsk, in Russia. At age twelve Rabkin was sent to a machinist school where he worked intensely long hours learning a trade. His father immigrated to the United States to find a job and a future in America. Like many immigrant Jews, he found work as a presser in a garment factory and sent for the family. The young Rabkin tried different manual jobs, working full time during the day and taking evening engineering courses at Cooper Union in Manhattan. He'd be so tired at night he would fall asleep and wake up in the dark, the only passenger on the subway car in the train yard. It was a long walk back to his Bronx home.

By 1920, after struggling as an owner of a machine shop, Rabkin started looking around for a new business. He found the Mutoscope Company. According to the erudite photo historian George Gilbert, who interviewed Rabkin in 1953 for an article in *U.S. Camera*, Rabkin bought the machines and the reels, planning to liquidate them for a quick profit. Instead, he held on to the newly acquired assets, and the company he formed then does a three-million-dollar annual business today in novelty machines and in the familiar coin box

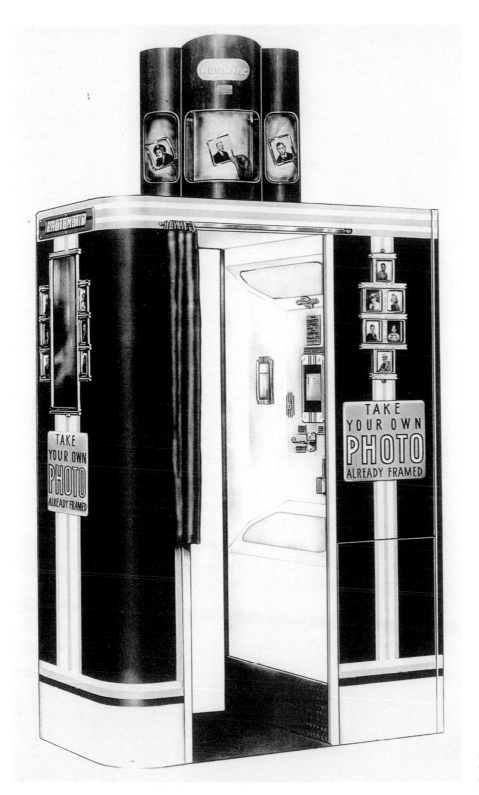

Mutoscope's Photomatic booth
with revolving photo display on
roof of machine, 1940s.

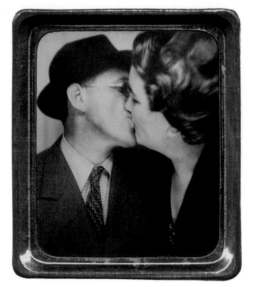

Mutoscope's Photomatic photo
1930s-1940s.

photobooths. The penny movies, which started the company, are now the smallest faction of his operation.

Gilbert remembers Rabkin saying, as he was talking about his surprise success with the Photomatic booths (for which he held several patents) and the Mutoscope movies, that he could have increased his income radically. Requests from Thailand and the Far East to produce pornographic short films for the Mutoscope flooded his office. He refused and sent them photobooths instead.

When he bought the Mutoscope Company with a partner, Rabkin acquired a warehouse full of old cameras and projectors in Hoboken. He later bought his partner out, moved the operation to Manhattan, and hired a bright and attractive secretary, Grace Baron. He started to make money and gained a reputation for extreme honesty in an industry known for pulling a trick or two.

By the late 1920s, with large orders from England saving the company from financial problems, Rabkin booked passage on the *Mauritania*. Taking his beautiful, creative, and hardworking secretary to preview the ship, he spontaneously turned to her and asked her to marry him. The business trip turned into a honeymoon. The couple abroad saw the new Photomaton in both London and Paris.

Returning to New York, Rabkin set up working with his engineers to design so many of his now famous arcade games. By the early 1930s Rabkin, as a trained machinist and designer, set out to design a better model photobooth.

Buying out the copyright of the Photomaton, the Photomatic was born. Designed in 1934, the Photomatic booth was half the size of a Photomaton. The

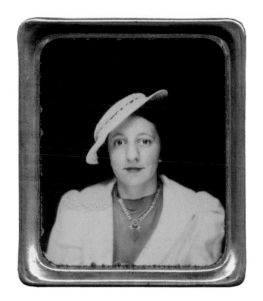
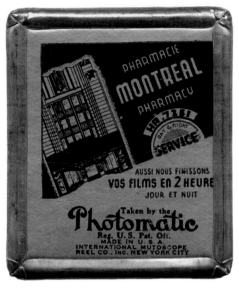

This French-Canadian Photomatic is probably from the late 1930s.

cabinet was fifty inches long, twenty-nine inches wide, and seventy-four inches high. It weighed a relatively light six hundred pounds. It was brilliantly designed to be knocked down into four parts and could be easily moved.

The engineers also had an artistic eye. They produced different models that gave the following options. The most popular and earliest model produced a metal-framed image. The company made additional money by selling advertisements on the back of the framed image. Later on, in the late 1940s and '50s, the Delux Photomatic models gave the option of two, four, or six larger photos on paper with no frame.

Whereas in the Photomaton the sitter would adjust his or her seat for height, in the Photomatic a simple finger knob adjuster would allow the sitter to move the lens to the appropriate height. This machine was an eye-catcher and could be ordered in any color.

The Photomatics could be privately bought. All paper film and chemistry would have to be purchased from Mutoscope. This provided a constant and very profitable cash flow for the company.

The chemistry used for developing the positive paper was very similar to that of the Photomaton. The motor used an air compressor. The chemicals were heated in a chamber where electrically preheated air passed through and heated the chemicals. The design and delivery of the single-frame image was radically different, however. The framed picture was exposed under a prism mirror that corrected reversal images. Then the framed picture was released into a central

A typical backing on a Mutoscope.

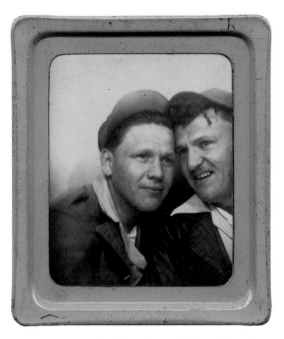

An example of a blue-framed Photomatic from the early 1940s.

chamber, where the developing and stabilizing chemicals were poured in order on the exposed picture, which was held mechanically in a horizontal posture. After a chemical was poured on the image, the picture would rock back and forth for a minute or so and the interior part of the frame would prevent the chemical, or the water wash, from running off. The frame would then be tilted at a forty-five-degree angle and the chemicals would run off into a waste receptacle in the lower third chamber of the booth. The top chamber was where the chemicals were stored; they were gravity-released.

William Rabkin and one of his engineers, Einar Larsen, worked on this booth and patented an improved Photomatic in 1940. By 1940 the Photomatic was big business. The average income in the United States was $1,729; the average yearly gross income for one well-placed Photomatic was $5,200. For the booth owners, or renters, the cost of the metal frames with advertising on the back was $30 per thousand frames. The cost of taking the photo was 25 cents.

From the mid-1930s to the early '40s, the only metal frames available were silver. Then gold frames appeared and were followed shortly by an entire rainbow of colors. On the back of the photo, special orders could include advertisements for wherever the booth was located. Martin Rabkin, one of William Rabkin's two sons, remembers hearing as a child the huge volume of banging noises and clatter as rolls of tin stamped out the frames. The attachment of the frame to the photo paper had to be done in the dark, as the photo paper was light sensitive, just like unexposed film.

What was America like in 1934? In the cities, unemployed people stood in line around entire blocks, waiting for soup and bread. For a significant number of Americans money was tight. The new president, Franklin D. Roosevelt, had just established the New Deal and the Public Works projects.

Anatol Josepho and his wife, Ganna, at this point had purchased property in Santa Monica, in an area called Rustic Canyon. This was a private, invitation-only community. All members belonged to a club called the Uplifters, which included many actors, artists, musicians, and financially successful citizens. Buying a huge tract of land next to the cowboy/entertainer Will Rogers, Anatol set up a separate building in which to work on his inventions. In the next twenty years he applied

for more patents. Other well-known inventions he was responsible for included an inverted screwdriver for orthopedic surgery and a single faucet for hot and cold water.

In America, during the Depression, the Mutoscope booths appeared everywhere. Normally the Photomatic ran on electricity but the company also made special models that could run on gasoline or diesel generators. This made it accessible for any location. The Mutoscope and Reel Company had the concession for the New York subway, New York's Port Authority, and all the photobooths at the 1939 New York World's Fair. Its holding company, called the National Photomatic Corporation, held the concessions for Penn Station, Grand Central Station, the Staten Island Ferry Terminal, and just about any other congested spot in the city. Rabkin discovered that even Photomatics placed in men's restrooms did surprisingly well.

All of these thousands of Photomatics were built in a five-story building the size of a city block in Long Island City, New York. Four hundred people were employed. Many of these people, it must be remembered, were assembling the Mutoscope and arcade games as well. There was even a small space with good lighting to shoot very small films for the old Mutoscope viewers. There were very good years and there were very bad years. As a rule, the Mutoscope Company sold the Photomatics to distributors who would either sell or rent the machines to operators. The company continued to make profits selling Mutofilm and chemistry.

Booths placed in busy spots would have to have the chemicals changed twice a week. An operator would empty the money tills. Photomatics in the 1930s, '40s, and '50s came under the umbrella of coin-operated games and under the same umbrella was a sometimes dark world. Though William Rabkin was well acknowledged as an honest and charitable person, not everyone else in the photobooth arcade world was. There may have been some shady characters acting as operators who did not report quite all of their income from the photo machines to the federal government. In other words, they pocketed tax-free income. There really was no way to document the income from the machines. For other questionable characters,

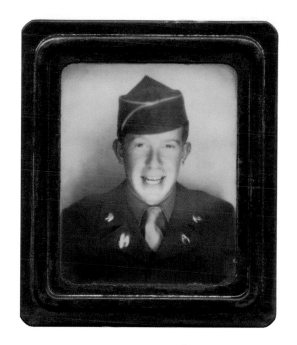

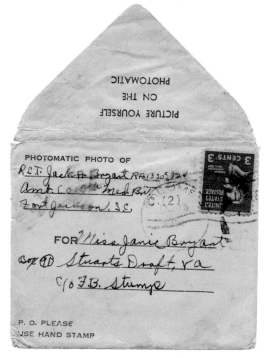

Photomatic photo with mailing envelope, offered in a vending machine attached to some of the Photomatic booths, 1940s.

who had large amounts of money to launder, they could declare the money as income from the photobooths, pay a tax, and then put the proceeds safely into their bank accounts. The police in New York City were so concerned about criminal participation that pinball and other arcade games were outlawed as forms of gambling.

During the 1930s and '40s, Rabkin continued to put in fourteen-hour days on the job. Marty Rabkin remembers his father so exhausted he would fall asleep at the dinner table or stretched out on the couch with one of his favorite cigars just lit.

By 1944 the photobooth was established as a popular and profitable business. Mutoscope, with the introduction of the Photomat, was selling machines on every continent. The body was made of a special automobile steel and finished in a variety of enamel colors. People ordering the Photomat booths could request any color or color combination they wanted. In the 1930s, the Mutoscope photo image, called a Photomatic, was a single photo in a metal frame. At some time during the Second World War, due to shortages of metal, the frames eventually became paper or plastic.

Mutoscope also offered, to the ambitious businessman, portable darkrooms where images could be enlarged right on the spot. The cost for this was $133.50. Color tinting outfits cost one dollar.

During the Second World War, most of Mutoscope's factory space was converted to the production of parts for Grumman Airplanes, sights for guns on tanks, bomb fins, and radar equipment. As mentioned before, the frames for the Photomatics were converted to paper and plastic. Some of the plastic frames had a mirror on the opposite side. None of these, however, had quite the glamour of the silver metal frame. Somehow the photo in the metal frame had more presence than a standard snapshot. There really has not been any other process quite like the Photomatic. The photos were soft and sometimes a little blurred, but the overall effect had grandeur. Though the photos were the ultimate pedestrian art, they captured a kind of Americana in the same way a Grant Wood or Edward Hopper painting does.

After the war, Rabkin produced a more sophisticated version of the booth called the Deluxe Photomat. Customers were now given the option of receiving a single unframed photo, double images, or strips of four images. In competition with the newly emerging Auto-Photo Company, the Mutoscope Photomat had to create a new internal delivery system.

While Rabkin and his fellow engineers were struggling to build a better photobooth, in the 1950s, they were also experimenting with designing a color photo-

booth, but the chemicals at the time were too unstable for this process. Another innovation that was years ahead of its time was linked to television. In the early fifties, TV was still uncommon in most American homes. Some of the better hotels had televisions playing in their lobbies. The Mutoscope Company designed a hook-up where, for 25 cents, you could take a photobooth photograph of any shot on the TV screen. This innovative idea created a one-of-a-kind image, but it was not popular and so was very short-lived.

After the Second World War Rabkin, who gave a great amount of his income to charity through a foundation he established with his wife, Grace, had become involved with the development of the Technion Institute of Technology in Israel. And who was also on the board with him? None other than Anatol Josepho, the inventor of the photobooth. These two men, who had so much in common, left no records of their meeting or conversation. If they had met earlier, which they may have, we will never know.

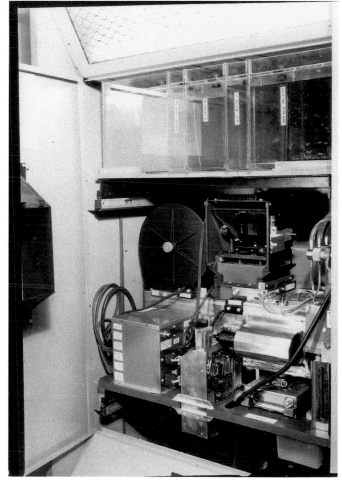

Interior of Mutoscope photobooth from the early 1950s. This model produced two photos on one large strip.

In 1954, Rabkin's twenty-four-year-old son Martin joined the company. Marty had just finished a degree in business and had other aspirations for his life, but he joined his father's business. He started on a Monday, as an assistant to the assistant sales manager. On the following Wednesday, his father was killed in an accident, and Marty Rabkin was suddenly the president of the Mutoscope and Reel Company. Within the next year, the top two executives also died. To make matters worse, Auto-Photo, Mutoscope's first real photobooth competitor in twenty years, was now aggressively marketing its new photobooth.

Marty Rabkin worked with his father's engineers to develop the Photomat into an efficient, profitable machine. For years the company had been working on a photobooth with a design for a photo strip. Their system was complicated and involved a series of Teflon "baskets," each of which was one and a half inches deep and wide, filled with corresponding development chemicals. The photo strips moved through a series of rollers in a U-shape inside each basket. After every twenty-five strips were developed, the baskets would be

automatically emptied and refilled. One of the big problems at this time was that Teflon was relatively new and the baskets kept leaking chemicals, so the sequence of developing was incomplete and a poor photo would result.

Martin did his best to keep the company and its four hundred employees going, but he was young and inexperienced. In the late 1950s, Mutoscope went into chapter 11 bankruptcy. Parts of the company were sold off; the rest was bought by two of its salesmen, Larry Gallanti and Joe Bertolucci.

The Photomatics and Photomats soon disappeared. Marty Rabkin married in 1960 and moved to California, where he worked as a documentary film producer, newspaperman, and successful businessman. Today it is almost impossible to find an old Photomatic. Once one of the most popular photobooths throughout the world, it is now almost totally unknown.

MIKE MUNVES

In the early 1950s Mick Munves and his brother, Joe, bought William Rabkin's Mutoscope business from Larry Gallanti. Moving from Rabkin's factory in Long Island City, the Munves set up their business at 557–79 Tenth Avenue at Forty-second Street in Manhattan. According to Al Kress, manufacturer of Benchmark Games, the new business needed this three-story building with a basement that took up one third of a block.

Gene Lipkin, former president of Atari and Sego Games, recalls the space as being a huge cavern, filled with old penny arcade games, photobooths, and lots of dust. Lipkin visited there with his father, Sol Lipkin, who was in the peripheral business of representing shuffleboards and pool tables. Gene remembers from his youth that all the operators and distributors for the vending machines, coin-op games, Photomats, and auto-photobooths would meet for coffee and hang out with Mike and Joe Munves.

Mike proclaimed himself the Arcade King, and with good reason. In the late 1950s and '60s, his business was the largest distributor in his field.

Eddie Adlum was formerly a writer for *Cashbox* magazine and is now the editor and publisher of *Replay* magazine, a monthly trade journal for coin-operated amusement games. According to Adlum, Mike Munves, like many of the earlier generations of New York immigrants, would sit in his white undershirt on his folding chair in front of his huge warehouse and banter with the salesmen as they walked by. His snarling dog, Rusty, would make sure people kept a respectful

distance. This hardworking man, who had come from eastern Europe, was a lot sharper than many of his competitors. On the third floor of the building, Adlum remembers seeing a pristine, almost museum-like collection of perfectly crafted, immaculate arcade games and Photomats. These mint games and photobooths were reserved for the phone calls from Hollywood where the prop people knew they could get the right equipment for the right movie. Movie and TV requests provided a source of tremendous income. Dick Greenberg, another eastern European exile, was constantly on the phone, growling orders and keeping the business running efficiently.

The Munves brothers and their colleagues were all self-made men. Believing in the American dream, they had found a niche where they could make a lot of money, retain their privacy, and incidentally provide a footnote to photohistory.

The Munves had a friendly competitor, Albert Simon in New England, who represented the new photobooth company Auto-Photo. The coin-op community was a very male world. Few, if any, women

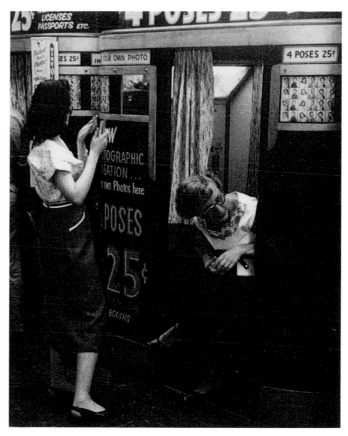

Times Square subway station, 1950s. Courtesy of George Gilbert.

sold or worked with photobooths or arcade games. Mike Munves designed and distributed a unique catalogue, which is highly treasured as a rare collectible today. With twenty-eight pages of photographic illustrations of photobooths, arcade games, and tools to repair these machines, Munves created the bible for the industry. On Tenth Avenue, the Munves brothers' building was settled in the center of the vending coin-operated world. Unbeknownst to them, the drive, reliability, and organization of the Auto-Photo Company (later Photo-Me) would ultimately eliminate the Photomatic photobooth.

Mike and Joe Munves were tough businessmen but also tremendously respected within their business community. As Gene Lipkin comments, "People like Mike and Joe represented a vocation where, no matter who you were, if you worked hard, you were guaranteed to be successful."

In the 1960s, engineers designed newer models of the Photomat photobooth to compete with Auto-Photo. The competing Photomat models arrived too late to

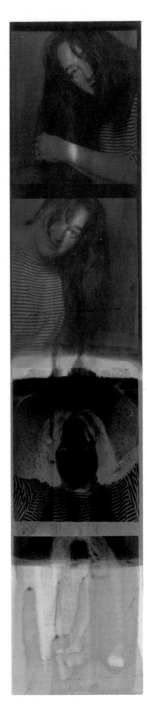
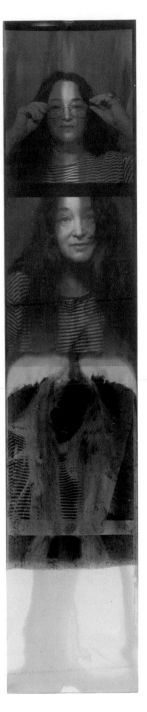

Self-portrait, Näkki Goranin. These two photobooth strips were only partially processed. The bottom of each strip has been dipped in water only, the second frame in bleach, and third and fourth frames in fixer. Not shown is the final chemical, a toner, which gave the earlier photobooths their distinctive finish.

catch up with the level of saturation, distribution, and, probably, exclusive agreements for booth placement that Auto-Photo had all over the country. By the early 1970s, the Munves brothers' business finally closed down. The two had spent their lives immersed in their work. The arcade world they represented has now been partially replaced by home video games.

In the early 1970s Larry Gallanti from the old Mutoscope Company tried to buy the Munves' business. He was too late and the business was sold to Ralph Hotkins and Joe Goldsmith, who moved it to New Rochelle, New York. Located on Huguenot Street, the company faded away.

THE AUTO-PHOTO COMPANY

As people all over the world were pasting photobooth photos in family albums, a new company was forming in the minds of two engineers named I. D. Baker and Gup Allen. By late 1945 the war had drawn to an end and, with all the returning soldiers, the American economy was refueling and full of great optimism. Allen and Baker had been working with the Keystone Engineering Company in California, producing World War II tanks.

Gup Allen, of Oceanside, California, had seen the old Photomatics and come up with the idea of a radically different engineered booth. He applied for a copyright in 1946. Forgoing the more complicated Photomat design, Allen went back to Anatol's original idea of running the exposed paper through separate baths. However, Allen's genius was in replacing the compressor engine with a transmission and a gearbox, and in developing a different design for the delivery of the paper and easily accesssible chemical tanks. The compressor was air-driven and used in the first two models that his new company, Auto-Photo, produced. The Model 7 was a prototype and the Model 9 was the first commercial machine produced. Allen's partner, Baker, took the design of the new

postwar photobooth and started the huge, mass-production plant in Los Angeles. Baker bought out Allen's copyright and, with a couple of investors, incorporated Auto-Photo. Decisions were made that affected how photobooths were perceived for the next sixty years. The new photobooth was to be built, produced, promoted, sold, and used in a tightly organized new business format. Customers with vending space would rent the booth. Camera art was suspended; commerce reigned.

Back in the factory, Gup Allen was busy updating the wooden Model 7 prototype to the more efficient Model 9. With competition from the still popular Photomatic, he needed to create a booth that was an eye-catcher, chemically and photographically efficient, and mass production friendly.

The Model 9 was Miami art deco at its prime. Bauhaus beauty. Curved, with a dark wood veneer and interior enamel face, simplified and elegant, this new booth was much more easily maintained than Mutoscope's Photomatic.

Even with the new design problems continued to plague the Model 9. Salts from the chemicals in a closed environment would clog the moving parts. The paper film would stick. Tension on the mainspring was so critical that a slight loosening would throw the whole machine out of whack. Air pressure had to be exact. The compressor, with its oil and need for air, created a blowing system of dirt. Think of a car engine in a stationary position. This machine had a one-armed delivery, which meant a two-and-a-half-minute wait between shots. Powerful floodlights faced the customer. The lens in the camera was set at a slower speed, so photos had a greater chance of being blurred.

In the late fifties, Auto-Photo produced the Model 11. The photobooth world was about to receive its most beautiful model. The timing wheel was replaced by a relay box and the interior arm was replaced by a spider with seven arms. The spider mechanism could process seven black-and-white photo strips in two and a half minutes. The floodlights were replaced by a strobe.

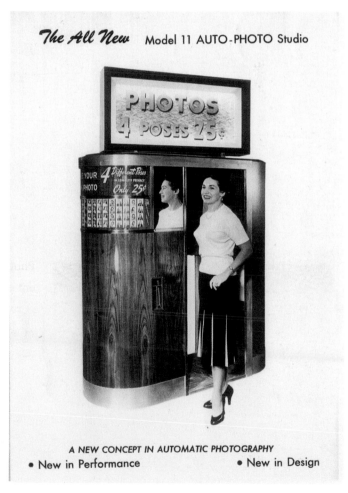

Auto-Photo Model 11, late 1950s.

At this time Van Natten, who was the vice president of Auto-Photo, set up a road map of sorts for the future of the company. The men he had hired had worked only in the jukebox and music vending industry. Van Nattan broke up the country into seven regions, each of which was run by a distributor. This meant each distributor was responsible for either placing Auto-Photo booths where

One of many ads placed by Auto-Photo distributor Norm Pink in Minnesota newspapers, 1950s-1960s. Courtesy of Norm Pink.

people congregated or selling them to operators who managed arcades, amusement parks, train stations, or fairs. Part of Van Natten's grand design was to establish a demand for the new machine. Heading his list were Woolworth's and Kresge's.

For the new operators, who had only worked with coin machines, a new level of sophistication was required. Van Nattan set up meetings with the new owners and operators and created an aura of respect, professionalism, and openness, which was nearly unheard of in the very competitive coin industry. One of Van Nattan's main concerns was keeping the quality of the photograph up to par. This meant constant maintenance and changing of chemicals. With the photobooths finding their way to small towns over a patchwork of regions, Van Nattan made another decision. In each of the variety stores, Woolworth's, and department stores where booths were placed, local assistant managers would be paid a small weekly fee to maintain the booths in their stores. They would mix the chemicals, pour out the exhausted liquids, and sweep the floor of the machine. In the 1950s and '60s, Auto-Photo would pay a Woolworth's employee $4.60 per week or $18 per month. An Auto-Photo maintenance man would do further work, but only two or three times a year.

Unlike the jukeboxes, the photobooths originally took a lot longer to get a return on the initial investment. The customer still paid 25 cents for four photos. The average income on a machine was $100 to $200 per week.

Model 11s started to show up everywhere. In the late 1950s and early 1960s, the Auto-Photo factory in Los Angeles was cranking out thousands of machines. Though Anatol Josepho was still in California, raising his family and continuing to work on his inventions, he had no known connection with the newest generation of photobooths. There is anecdotal evidence that he and Edwin Land, inventor of the Polaroid, corresponded in the late 1940s and '50s, but many of Land's papers were destroyed after his death. This was also forty years before the Polaroid company commercially entered the Photobooth world with Polaroid and digital photobooths.

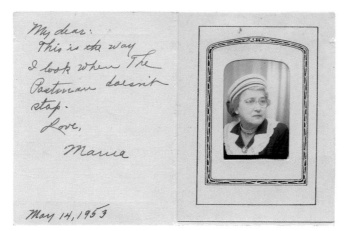

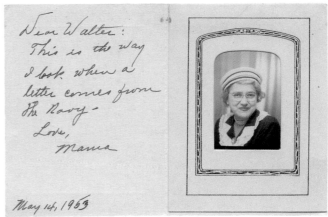

Everyone loved sitting in the booth, making faces, kissing, squeezing in friends. Yet no artists were using photobooth images seriously in their work. No art or photography schools included them in the curriculum. This medium was totally ignored by the photography community. While Americans were busy in the booths, smiling, frowning, drinking, taking off their clothing, the rest of the world were using the booths strictly for identification and business purposes.

Auto-Photo photobooth shots with folders sold by the company.

As early as the mid-fifties, however, Auto-Photo had an unexpected problem. Complaints started coming in, from Woolworth's and other stores, that people, particularly women, were stripping off their clothes for the private photobooth camera. Couples started being a little more adventurous in the privacy of the curtained booth. As a result, many of the Woolworth's stores had to remove their curtains to discourage naughty encounters.

In Hollywood, photobooths were demanding attention. In the 1953 film *The Band Wagon* with Fred Astaire and Cyd Charisse, Astaire performs a number where he dances into a Photomatic, sits for a photo, the flash goes off in time to the music, and he dances out. In 1957, *Esquire* magazine lugged one of Mutoscope's art deco booths into Richard Avedon's New York studio. According to the article, Avedon "has long asserted that true photographic talent cannot be restrained by a camera's technical limitations." The *Esquire* editors picked celebrities and challenged Avedon to produce photographs. The resulting Photomatic essay is stunning, including images of Marilyn Monroe, Audrey Hepburn, Truman Capote, and Ethel Merman.

Cartoon made for Auto-Photo convention, 1950s. Courtesy of Norm Pink.

65

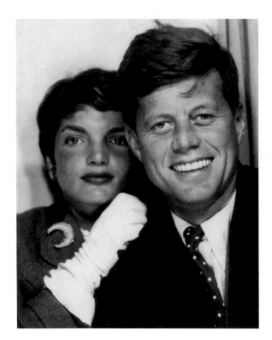

President John Kennedy and his wife, Jackie, on their honeymoon, 1953. Courtesy John Fitzgerald Kennedy Presidential Library and Museum, Boston

Auto-Photo, in the late 1950s, also tried to market a radical Model 11A. This model was stripped of any decoration or curtain. A numbered strip could be held or inserted on the photo. The machine was designed for police and prison mug shots. The Auto-Photo company so got into the police mind-set that they also tried to market a photobooth with wheels that could be rolled out to riots and other civil disturbances, so that participants could be photographed and tagged right on the spot, even if not arrested. The sight of an eight-hundred-pound photobooth being wheeled from ballpark to bar never seemed to take off and civil liberties lawyers lost a profitable avenue. However, today photobooths are still used in some prisons for mug shots and, in their public areas, for prisoners to take photos with visiting families.

In 1964, Auto-Photo introduced its last and most successful black-and-white chemical booth, the Model 14. Made with steel and Formica, this machine is a modern, sleek booth that is highly dependable and a little easier to move than earlier booths. Van Nattan was still running the distributorship and pushing for more and more saturation of machines on the street. Some individual booths were so successful that they drew in $75,000 a year. Surprisingly, little mention of the success of the photobooth industry appeared in financial papers.

From the 1960s through the 1990s, there was one "outlaw" operator, the former mayor of Utica, New York, Ed Hanna. Starting as a distributor and then as an operator with Auto-Photo, he was a controversial character who, as mayor, removed the door of his office "so everyone could see him anytime." He got into a dispute with Auto-Photo and started his own company. He contracted with Eastman Kodak to have the positive paper made. (Ansco in France was making the paper for Auto-Photo at this time.) Hanna himself started packaging the chemicals. Corralling customers from the Auto-Photo herd with warmth and charisma, he built a profitable business for himself, until his retirement in the nineties.

Meanwhile, Brian Herren took over the Auto-Photo Company, and it continued to pull in dollars. Now owned by the large multinational photobooth company called Photo-Me International, the Europeans had full financial control. Based in England, under the leadership of Dan David, a new business plan was initiated in the late 1980s to early 1990s. Thousands of Models 9, 11, and 14 were junked. Trucks filled garbage dumps with chemical photobooths that were con-

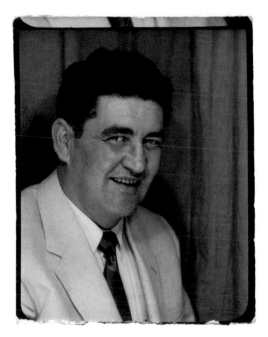

Photobooth image with promotional stamps, 1950s–1960s.

sidered obsolete. Digital photography was the new agenda. Black-and-white photographs were thought to be passé.

In the mid-1970s, the chemical booths producing color strips became big sellers. By the 1980s, Auto-Photo was working out of a small, square factory. The ten-thousand-square-foot building in Tustin, California, was so small that the thirty or so repairmen had to move the booths into the parking lot to work on them. Somewhere in this time frame the manufacturing of chemical photobooths was phased out.

In the mid-nineties, the company moved to Texas, retaining many of the old staff. Alberto Caroselli was president of the American company, Matthew Carter, the chief financial officer, and Tom Rockowski, the chief manager and engineer. The company briefly changed its name to Image Dynamics when it merged with Irati. Then, taking its new name from its parent company, it is today called Photo-Me USA LLC.

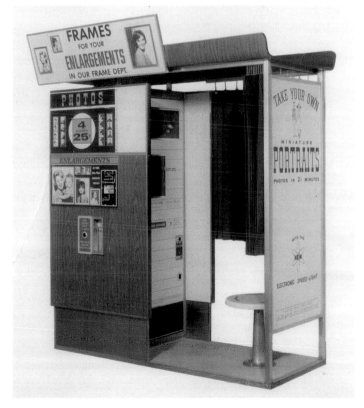

Auto-Photo Model 14.

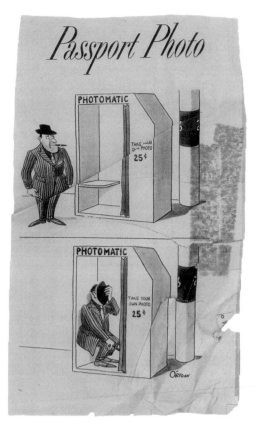

One of many photobooth cartoons from the 1950s. Cartoon by O'Brian. Courtesy of Norm Pink.

The Photo-Me USA machine is the best-known booth to the American baby boomer generation and their children. Working in the past under the leadership of a variety of knowledgeable people such as Jerry Schill, Jim Henderson, and Peter Godfrey, the black-and-white booth provided a photographic magic unlike any other camera format.

In the 1990s, Photo-Me started promoting digital color photobooths using a computer and printout paper. Gary Gulley, who was the American voice of the company for many years, acknowledges that even with Photo-Me encouraging customers to use the digital booth, people continued to crowd the few old black-and-white chemical booths. While color chemical booths have been popular, the digital booth, with its flat images, did not meet the company's expectations. According to Matthew Carter, as costs of chemicals and photo positive paper rise the temptation to design a superior digital machine that still looks like an old vintage machine is on the company's wish list.

There really is nothing comparable to the old black-and-white photobooth, the small private photo studio with the hidden darkroom. Even today, some eighty-plus years since the first Photomaton, the phone calls continue to come into the main Texas office. The frequent requests are from people desperate to retrieve what the customers believe are negatives of photos taken the night before. Bambi Torres, Photo-Me's walking encyclopedia of mechanical facts, has to constantly reassure people there are no negatives.

Photo-Me's main source of income for these older booths is the fees paid for the constant replacement of rolls of photo paper and the developing chemicals. Mechanical upkeep provides another source of income. A few booths owned by the company produce an income in the neighborhood of four thousand dollars a month.

Today's Photo-Me USA company has a majority of chemical booths in its inventory. Most of these booths are color. There are only twenty-five working black-and-white machines the company uses. However, there are about two hundred black-and-white chemical booths in this country that are privately owned and operated. Some of these are in Hollywood homes. Director Brett Ratner has a photobooth in his house and has published a book of photobooth strips of his friends. Musician Dave Navarro published his own images as well. Quentin Tarantino and Gary Busey are rumored to own photobooths.

When the French movie *Amelie* was released in the states, Gary Gulley comments that the number of phone calls to buy or rent booths significantly increased. *Amelie*, an enchanting film, tells the story of relationships that revolve around a French Metro photobooth and an album of photobooth images.

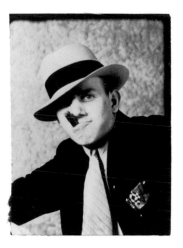

Photobooth image from the late 1920s.

CANADA TODAY

Canada imported Photomaton studios in 1927 to its widespread metropolitan cities. In addition to the phototerias, most of these machines were updated in the 1930s to Mutoscope Photomats. Machines were independently owned and supplies ordered through the New York company. As in the United States, small independent photobooths were also scattered throughout the provinces.

In the early 1950s, Samuel Grostern, a Montreal clothing manufacturer, went to a convention in New York City. Seeing the popularity of the brand-new Auto-Photo photobooths in Times Square, he shrewdly bought the rights for Canadian distribution. With no background in photography or vending machines, and together with other family relatives, Grostern built up a major Canadian business extending over great distances to all the provinces and territories. Now a three-generation company, son George and grandson Jeff, both trained accountants, own more than five hundred widespread photobooths. George Grostern, after taking control from his father Samuel (who lived well into his nineties), came up with the idea of designing each photobooth to match the decor of the different shopping malls and amusement parks where the booths were located. George's most spectacular design was a booth built like a French Gothic castle.

Many of the Canadian black-and-white chemical booths, like their European counterparts, are being shifted over to digital systems. Today, to the Grosterns' happy amazement, the photobooth industry is experiencing a major upswing in popularity. Selling photobooth supplies, as well as the photobooths, to both Canadians and Americans, Montrealer George Grostern has found himself a magnet for the new cult of Canadian photobooth lovers.

A North American Photo-Me photobooth in a shopping mall, 1990s.

TODD ERICKSON

Most state fairs had at least one photobooth somewhere on the grounds. In Minnesota, state fairgrounds were established in St. Paul in 1885 on two hundred acres. The penny arcade was built around 1910 by Tommy Shogren and a female

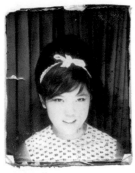

Photobooth picture from the early 1960s. Chemical stain from improper washing. Photo will fade but the message endures.

partner whose name has long been forgotten. Shogren had the traditional Muto-scope games, electric fortune-telling gypsy, and pinball machines. In the early 1950s, after finishing his military service, Todd Erickson inherited the arcade. This was about the same time that the modern Auto-Photo booths were being heavily promoted. The young Auto-Photo distributor Norman Pink, full of enthusiasm and a genuine love for the booths, encouraged Erickson to start renting the new company's photobooth, which was the beginning of a forty-year love affair with the booths. Erickson had so much success with income from the machines that he tried to buy more booths from the company. At that time, Auto-Photo was rigid about selling any of their income-producing booths, so Erickson bought his first booth from charismatic Ed Hanna, the maverick of the photobooth world.

With a strong background in engineering, and a desire to make anything good better, Erickson, after years of doing maintenance on the machine, redesigned a better, more efficient photobooth. After 1980, strictly black-and-white photobooths, as well as some of their parts, were no longer being produced. So Erickson substituted "solenoids" from washing machines. X-ray machines had been cannibalized for capacitors. As for all the other photobooth moving metal parts, Erickson removed them, had them glass-beaded, and then baked in Teflon. This process not only makes the parts last four times longer, but it is also easier to keep the machine's interior clean.

Passion turned to desire and desire turned to ownership of fifty booths. With so many vintage booths in his living space, the next logical step was to start renting them. Now, using a set of "booth wheels" of Erickson's design, the booths are rented out for social occasions. With Todd's son, Nicholas, in the business, the Erickson trucks today travel the roads throughout a six-state area. Norm Pink, who was one of the most successful distributors for Auto-Photo, still works in St. Paul in the entertainment business.

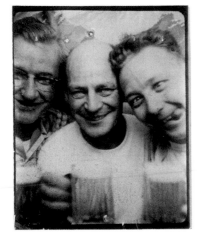

In the beer tent at the St. Paul Fair. Courtesy of Todd Erickson.

FANTASY ENTERTAINMENT

In the 1990s, as digital and alternative-style photobooths were being developed, by old and new faces, a Japanese company started importing the first digital sticker booth, called the Neo-Print, to the States. Kodak, in an attempt to diversify, built sticker booths to be used initially in Japan for the Olympics. At this time, sticker booths were wildly popular among Japanese schoolgirls and drawing the attention of worldwide photobooth companies as a possible future invest-

ment. Kodak, flush with the success of the booths, flew the machines over to the States and had them wired for e-mail and set up in American chain stores. The expected wave of mass attention never happened. The typhoon of Japanese success ended at our shores. Kodak, after rethinking the prospect, sold the machines to Fantasy Entertainment of New Hampshire. As Fantasy started promoting the gospel of digital machines, its novelty cost Photo-Me about half of its business. As a result, this is when Photo-Me started junking most of its chemical booths and tried to evolve digitally. Fortunately, they still retained some of the black-and-white chemical booths that today, ironically, are the largest part of their American income.

Fantasy Entertainment, however, with a significant promotion and presence, is making itself well known in more than three thousand malls, arcades, and movie houses in the United States. Owned by Kyle Nagel, the company is also represented in Canada and some thirty countries worldwide. Their digital booths offer character sketches, sticker images, and eight multiple images on a sheet, with new ideas constantly in the pipeline. An Auto-Photo-style digital photo strip is also represented. As in Japan, Fantasy's biggest customers are teenage girls.

In close competition with Fantasy is Apple Industries, out of Baychester, New York, owned by Allan Weisburg, who like others in the industry came from

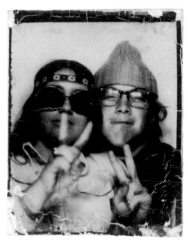

Two "flower children" in an anti-Vietnam War peace gesture, early 1970s.

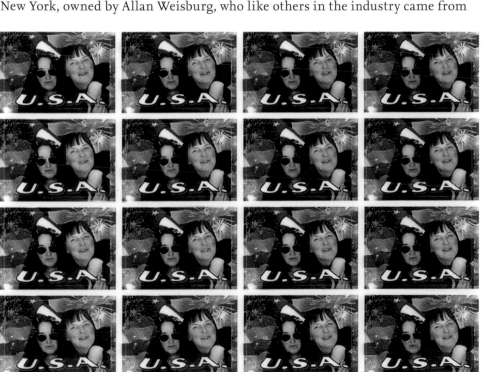

Digital novelty photobooth stamps distributed by Fantasy Entertainment, 2001.

a family history of a father who had also been in the business of coin-operated machines. Abraham Weisburg had experienced his own problems with the growing vending and photobooth business, the least of which was dealing with Al Capone and Crazy Joe Gallo. These two well-known tough guys in New York City were making cash demands again on the distributors and operators of vending machines and photobooths. Mr. Capone tried to manipulate union rules and sometimes the results were, as Allan remembered, seeing employees of his father after a run-in with a baseball bat. After the death of Gallo, the pressure was taken off the industry and, by the 1980s, was no longer an issue.

Today Apple Industries also has a variety of digital booths that include the stickers, changing backgrounds, costume design, and postcards. The most popular of their machines is still the black-and-white strip.

Allan Weisburg, who grew up seeing Albert Simon's Auto-Photo warehouse and the Munves brothers' warehouses, now runs a photobooth business that he truly loves.

Other people who had worked for Auto-Photo in the 1970s and '80s set out to go into the photobooth business for themselves. In California, Jim Henderson and Larry Kadillac, among others, have designed their own versions of booths and have succeeded quite well in the new trend of renting and selling booths.

Photo-Me USA, aware of the renewed interest in the chemical "dunk" machines, is apparently committed to continuing manufacturing both the paper strips and the required chemistry. As of this time, the paper is manufactured in Russia. Because of the shift of so much of the photo industry from film to digital, it will be more and more of a niche market to continue providing supplies for the older booths. But sometimes what is old is new again, and maybe Photo-Me in a twenty-first-century leap of faith will again start producing what there seems to be no substitute for, the object of Josepho's dream, the twenty-first-century Photomaton.

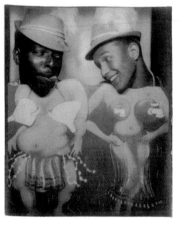

Photobooth image from a fairground, 1950s.

STEVE HINES

A variation on the photobooth was invented in the early 1990s by Steve Hines. As a ten-year-old, Hines had become obsessed with all forms of 3-D and stereo images. Unlike most kids who live out their 3-D fantasies at the movies, Steve grew up to be an optical and mechanical engineer. Working first for sixteen years as a senior research physicist at Kodak, he continued his experiments with 3-D.

Moving on to Disney and Epcot Center, Hines worked with research and design to create optical illusions. For the photobooth lover, one of his most exciting inventions is the 3-D photobooth. Using an already manufactured Capcom, a Polaroid photobooth, he made modifications to the booth, the camera, and the lenses. Using an anaglyphic (3-D) background, the final photobooth image is unique. Without glasses, the photo looks normal. With the red-and-blue paper glasses on the image jumps out at you. With not much publicity, the booth has not gotten the attention it deserves. As Polaroid booths never really succeeded financially, this 3-D booth idea could still create a lot of attention in the right setting.

ANDY WARHOL

Well known as a star of Pop art, Andy Warhol was also the first art promoter of the photobooth. Starting in the late 1950s and through the 1960s, Warhol understood the photobooth as a cheap and effective camera, producing photographs that cut to the bone an image perfectly suited for graphic design.

When Warhol looked at the black-and-white photostrip, he saw it fully expanded. Like a gardener seeing the flower as he looks at the seed, Warhol envisioned the color and sense of movement the artist could achieve by combining a variety of poses from the booth. He also used just one frame reinterpreted in different colors and superimposed line drawings. Warhol's genius was in expanding the ordinary. The straight simple photobooth and, later, Polaroid shot metamorphosized when it was reinterpreted with silkscreen, paint, or diamond dust.

Warhol sent his wealthy subjects to an arcade at Broadway and Forty-seventh Street in Manhattan. Among the flashing Mutoscope games and smells of popcorn and urine, Warhol would have the sitters go from photobooth to photobooth until the artist found one he liked. The booths in the arcade would have been the old Auto-Photo Models 11 and 14. The reason for trying different machines was that the depth of the black-and-white tones on the

Time magazine cover designed by Andy Warhol using photobooth images. This was the first time photobooth images were used as serious art. TIME Magazine © 1965 Time Inc. Reprinted by permission.

Photobooth strip of Andy Warhol. Copyright © 2008 Andy Warhol Foundation for the Visual Arts/ARS, New York.

print would have been dependent on how fresh the chemicals in each machine were. The more a photobooth was used, the more exhausted the chemicals would be. If the chemicals were going bad, the photobooth pictures would become grayer and seemingly out of focus.

In 1963, Warhol challenged the traditional commercial portrait world with his inclusion of photobooth photos of models in *Harper's Bazaar* magazine. In 1964, Warhol started to use Times Square photobooths in serious images that evolved into a series of self-portraits and paid commissions. In 1965, *Time* magazine hired Warhol to produce a cover on American teenagers; he used the sons and daughters of the executives of *Time* as photobooth subjects.

Warhol, like everyone else, kept hundreds of photo strips of his friends and all the wannabes who walked into his life. For a short time at the Factory, which was his studio and social center, he had his own Auto-Photo booth. The booth was his presence, though he was not there much of the time. The omnipresent booth took visitors' pictures. Later, some of these photos were silkscreened. With groups of people following Warhol's directions, hundreds of these silkscreens were churned out and Warhol put on his final touches and cashed the checks.

The influence of Warhol's work continues to grow. His sense of graphic design and representation of popular media images continue to strongly influence the commercial art world. Warhol's photobooth images will continue to be rediscovered by each new generation who, in turn, discover the photobooth.

PHOTOBOOTH ARTISTS

For the children of the late 1940s through the 1980s, before the digital revolution confined new generations to their computers and game boxes, most children, regardless of their backgrounds, sought out photobooths. Standing outside the machine and listening to the chugging and clinking of metal against metal and gears shifting, both children and their parents wondered what was going on inside this mysterious photographic cabin. The anticipation of waiting for three minutes, which felt like an hour, curious about how you would look and who was squeezed out of the picture frame, was all part of the fun of having your photo taken.

When the four-framed photostrip slid out, wet, shiny, and with an odd chemical smell, everyone grabbed for it, wanting to be the first to see it. People laughed, moaned, or smirked at their likenesses. No one remained passive.

As some baby boomers started to develop into artists, small art shows featuring photobooth images showed up on both coasts. In San Francisco, there was a small show by a male artist, unknown to me, who took a series of self-portraits in different bus stations throughout California. In the seventies, George Berticevich on the West Coast, Jared Bark driving across the United States, and Herman Costa in New York City started doing series of abstract portraits of either themselves, friends, or complete strangers. Ultimately, their work, along with the work of a few other artists, ended up in a show, first in New York City and then in Rochester, New York. The 1987 exhibition, called "Photomaton," was curated by Bern Boyle and Linda Duchin. In a small booklet, put together for the show, based partially on Claire Connor's *Village Voice* article, Boyle wrote the first known American pamphlet on the photobooth's history. The show drew enough attention (partially through Boyle's gallery contacts) that most of the young participants sold a photobooth piece to a major museum. Bern Boyle, a New York postcard artist and an active participant in the parade of New York art trends, never saw the ultimate renewal of interest in the photobooth. An early victim of AIDS, his perception of the artistic value of photobooths, sidewalk photography, and home snapshots is now being realized.

Herman Costa, a Vietnam veteran and major photobooth artist, took the lead from Warhol and, following Warhol's death, was asked to create photobooth advertisements and illustrations in Warhol's *Interview* magazine and *New York* magazine. The Museum of Modern Art in New York bought one of his larger pieces and, as late as 1993, MTV asked him to create an American flag photobooth mural for the cover of the invitation to their presidential inaugural ball. As the

Self-portrait with Grandmother's Mexican Blanket. Näkki Goranin, 2001.

Photomaton cover by artist Herman Costa. Produced for a photobooth show, installed by Berne Boyle and Linda Duchin.

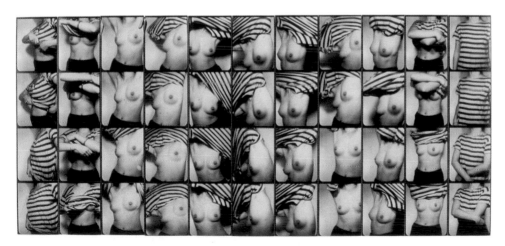

Unknown woman. Copyright © 1983 George Berticevich.

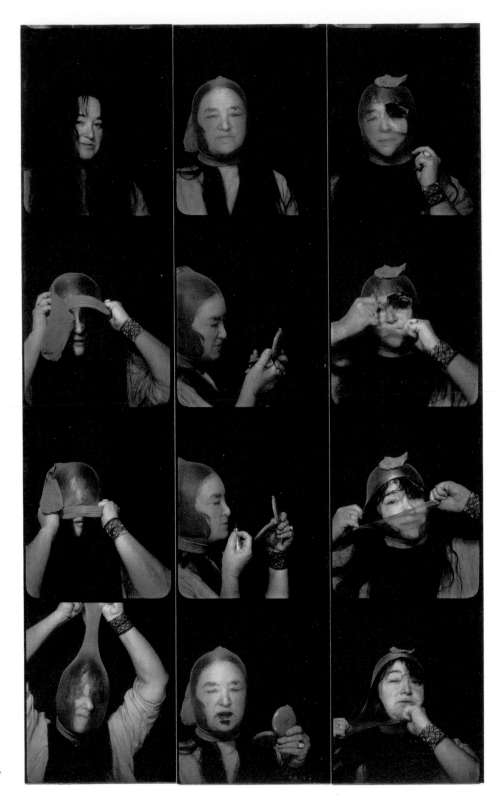

Nylon head. Näkki Goranin, 2004.

76

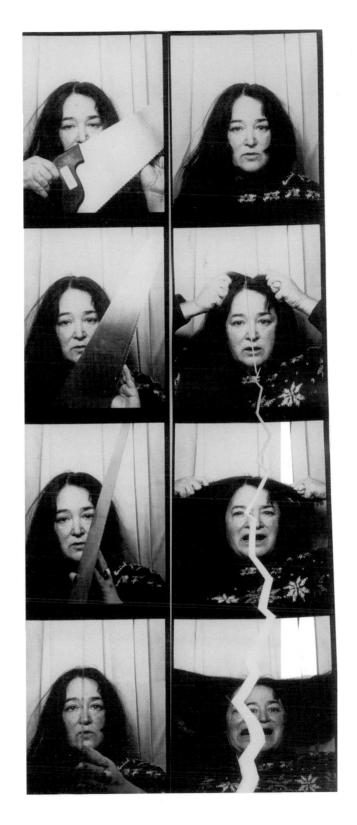

See-Saw. Näkki Goranin, 2004.

old chemical black-and-white booths became harder to find, Costa moved on to new adventures. Working today at a nonprofit organization, he has focused his life on creative writing and performing as a dancer.

Liz Rideal, another participant in Boyle's exhibition, is back in England and is a major teaching figure in the photography world. She continues to do huge photobooth murals in England, with European shows.

Very few photobooth artists have emerged in the past thirty years due to the lack of accessibility of the machines and the cost associated with either using them or actually buying a photobooth. I myself, a photographic artist in Vermont, found an old working booth in the back of a toy store in the mountain town of Bristol. Spending time and hundreds of quarters at Folkheart, the store became my part-time studio. The strips of photos made me think of frames in an old film. Scripting narratives, small stories could be told in four, eight, twelve, or sixteen frames. The challenge of moving objects and costumes in a space of a second or two created more spontaneity, and sometimes surprises, in the final images.

After showing self-portrait photobooth photography in different galleries in Vermont, I bought a used 1960 photobooth from Photo-Me and have been ferrying the booth around to different studios, as it cannot fit through the doors of my house. With a love of photo history, I decided to write the North American history of the photobooth and spent five years digging out unpublished and almost-lost information. It seems everyone in the vending industry who worked with the booth retained some love of the machine and was more than glad to share their memories and sometimes records. In the process of my research, I have collected more than three thousand historical photobooth shots and historical papers relating to the industry.

Self-portrait, Black. Näkki Goranin, 2001.

Self-portrait, Series on Spirituality. Näkki Goranin, 2005.

Today, as fewer and fewer of the old-fashioned chemical photobooths survive, this American tradition stands on the threshold of extinction. As the digital camera and digital photobooths write their own destinies, the hope is that someone somewhere will continue to produce the narrow, chemical-coated photo paper needed for the great old machines. For some experiences there is no substitute. I have never met anyone who didn't have some fond childhood memory of moments spent in that little photo house.

Self-portrait with Amelie, Näkki Goranin, 2003.

PLATES

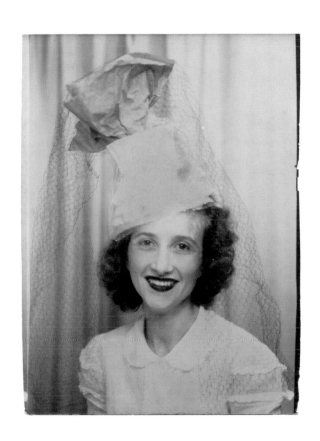

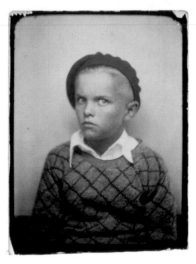
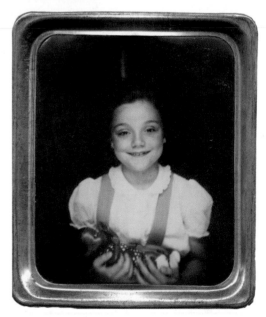

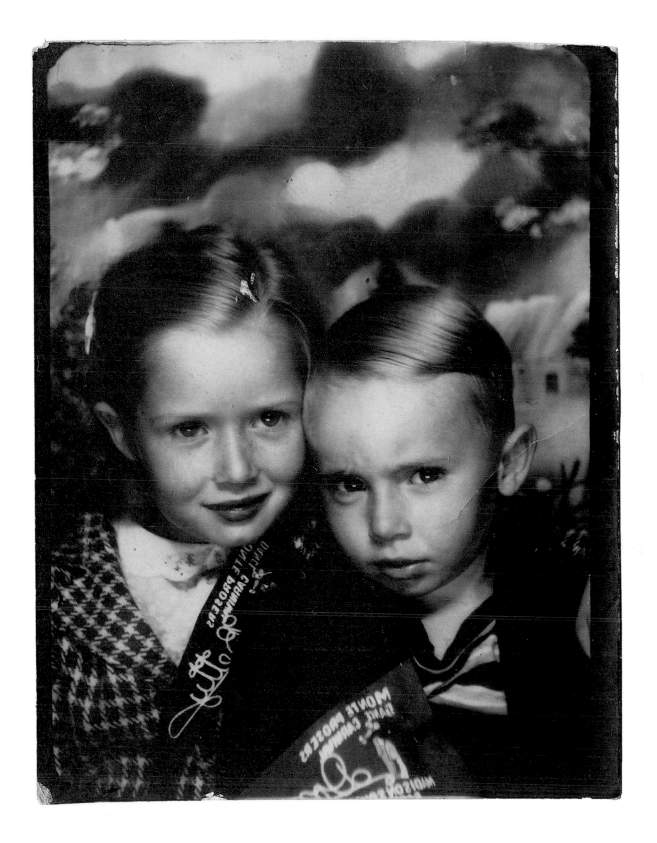

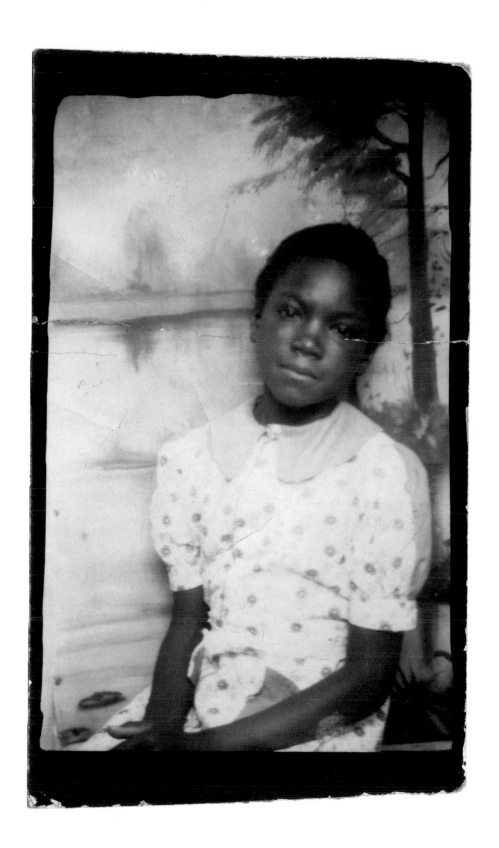

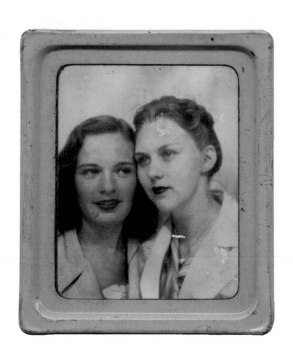

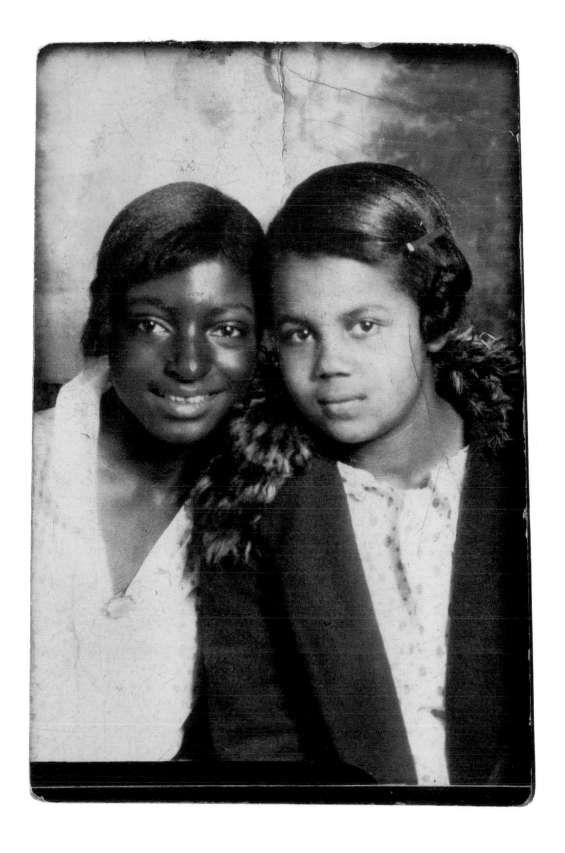

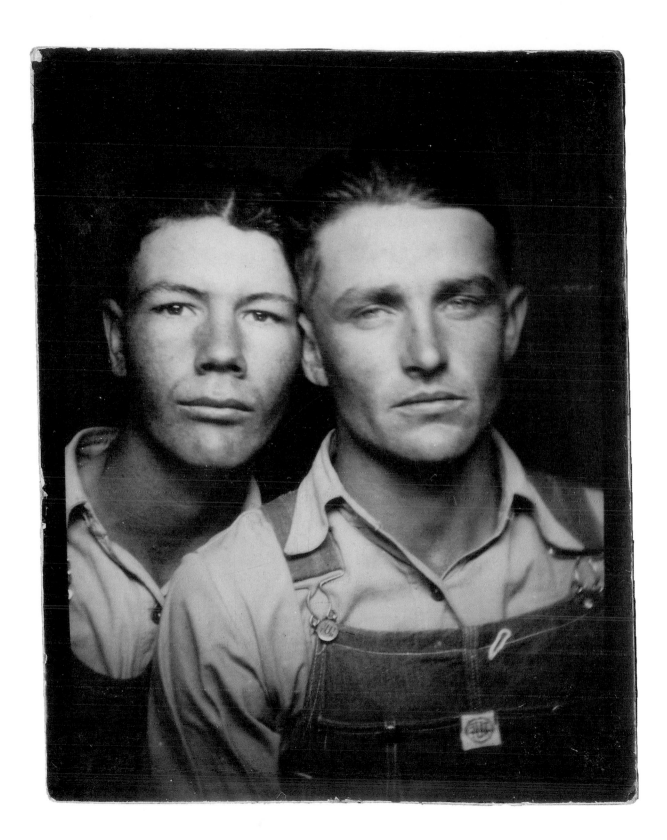

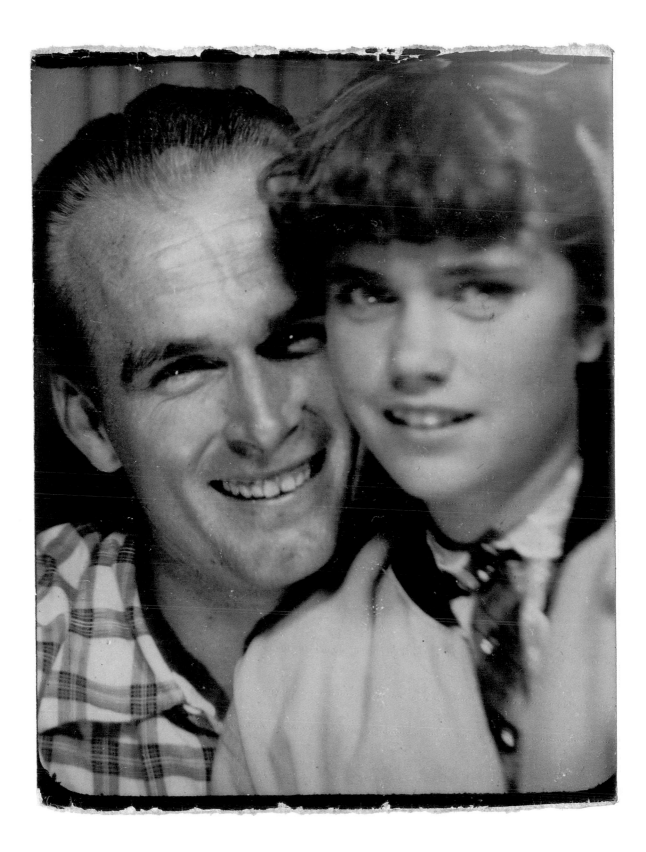

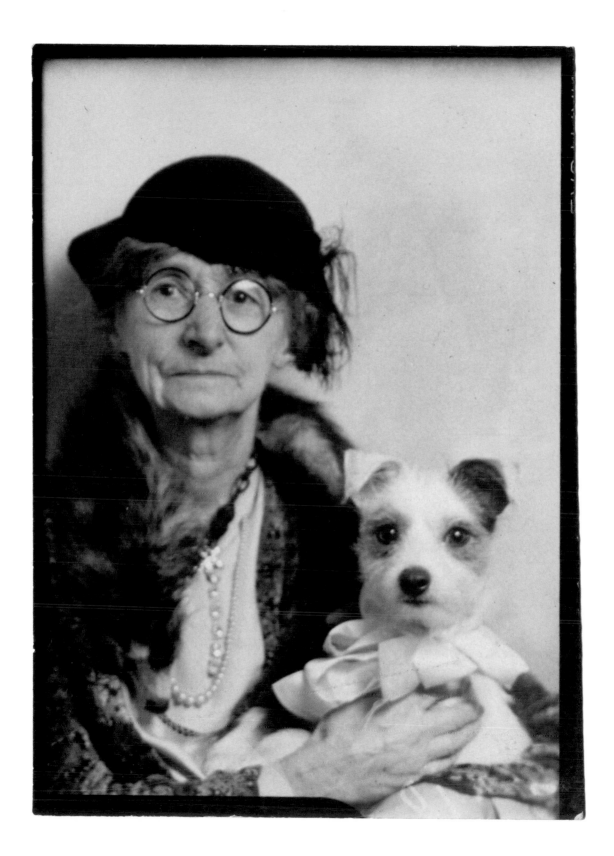

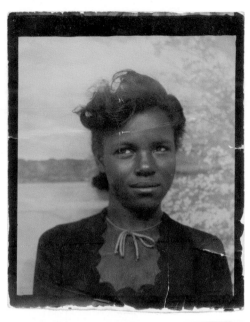

94

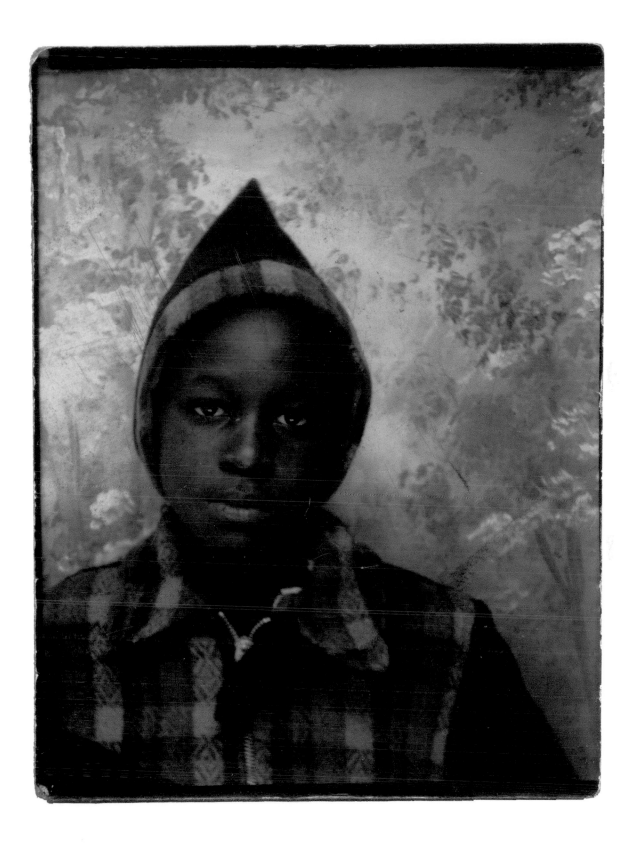

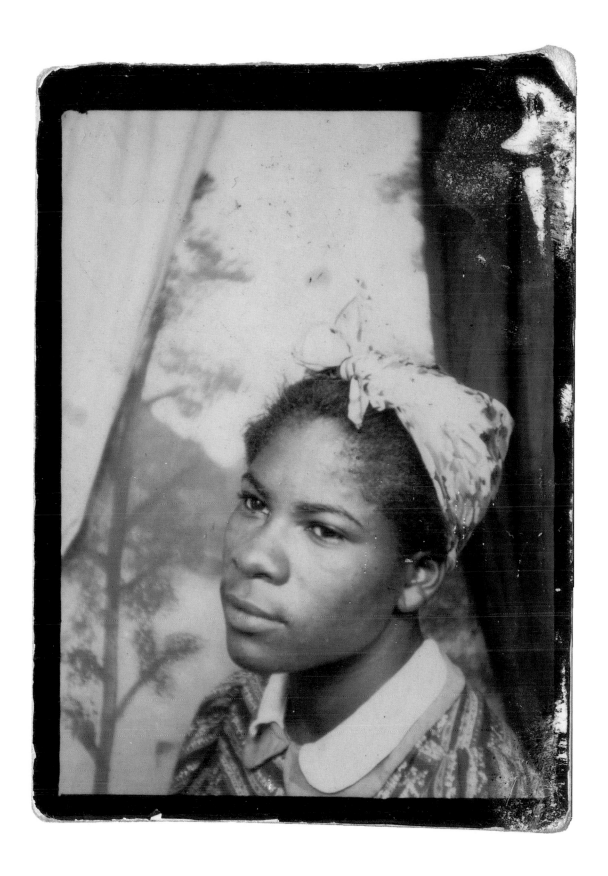

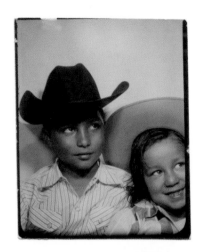

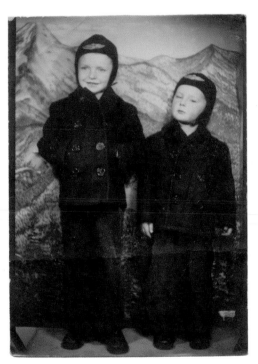

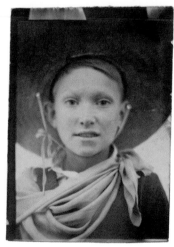

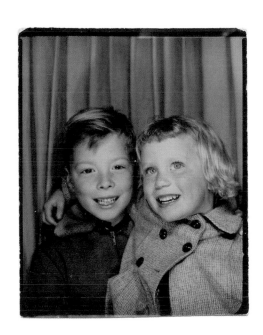

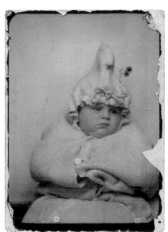

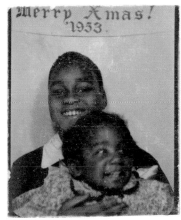

Merry Xmas!
'1953.

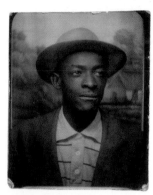

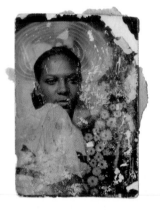

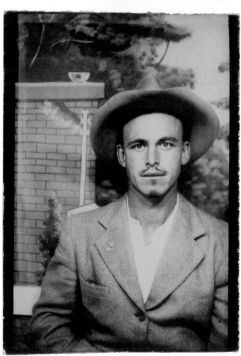

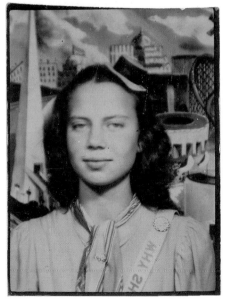

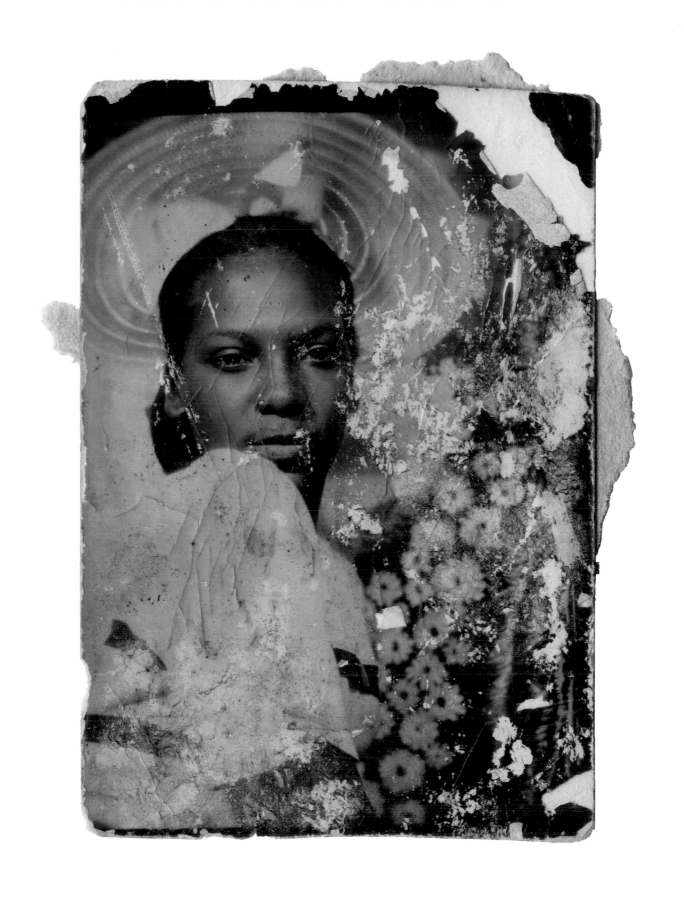

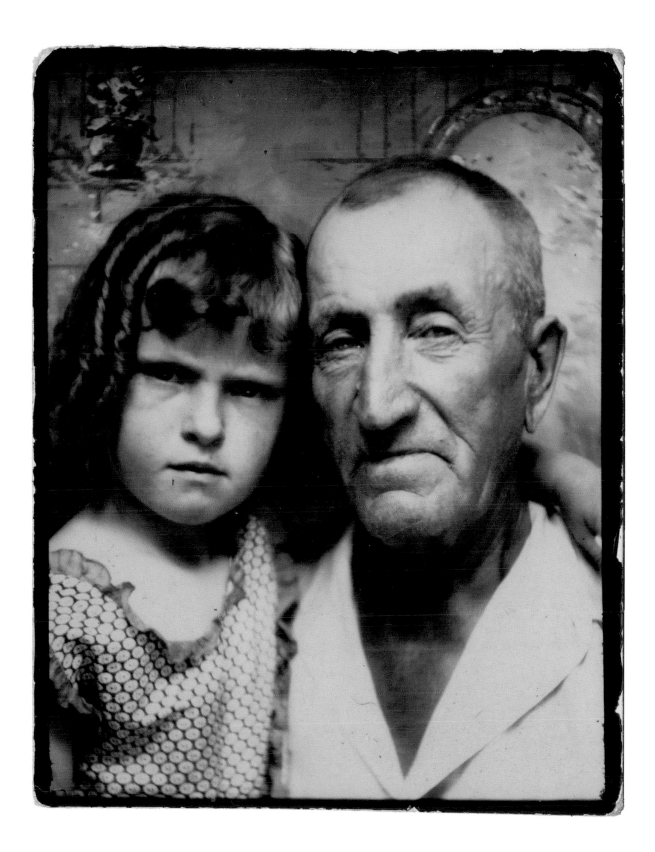

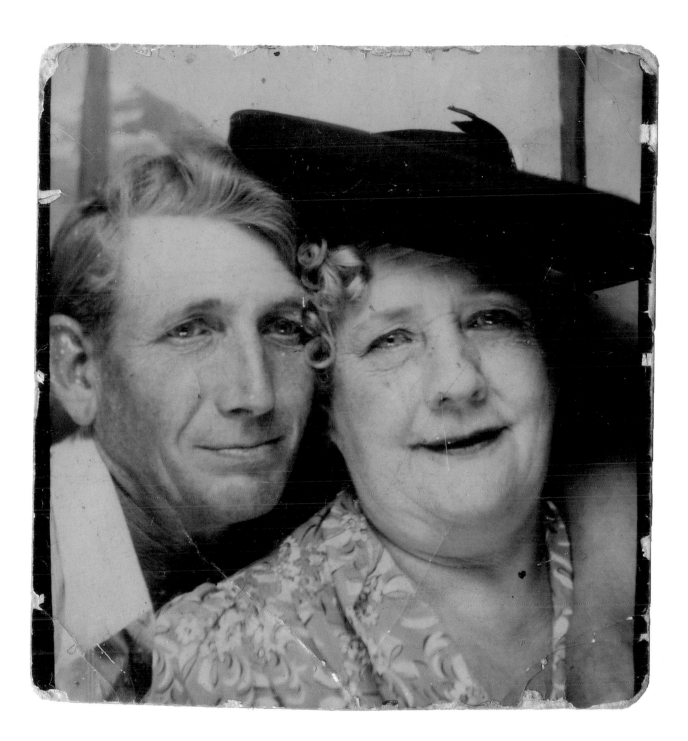

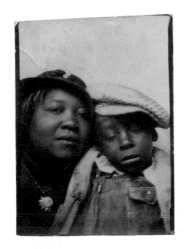
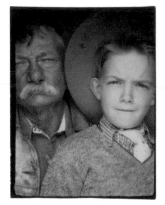

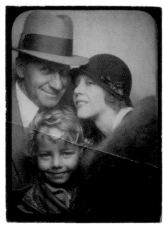

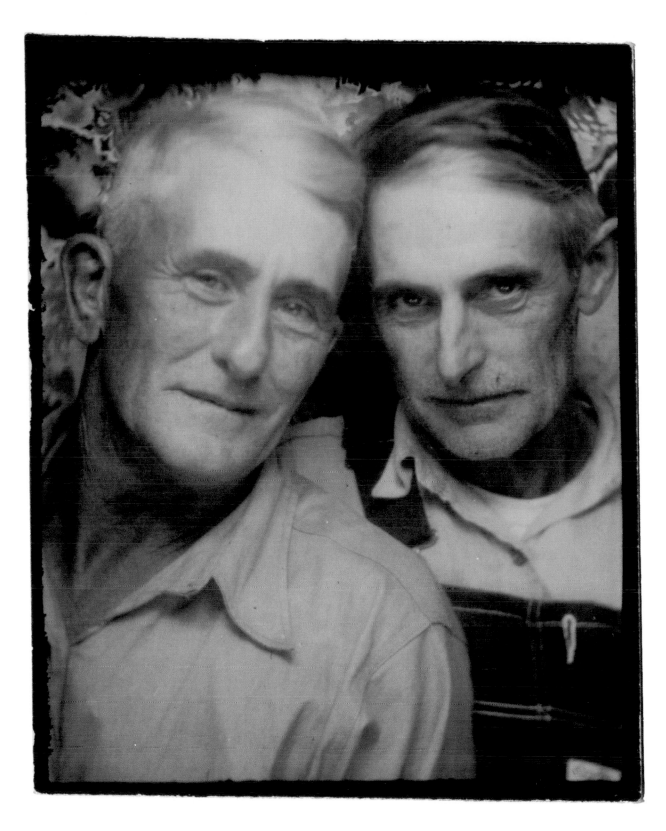

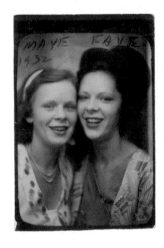

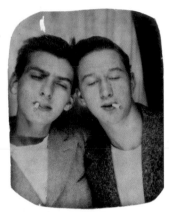

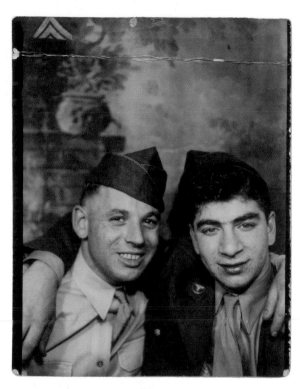

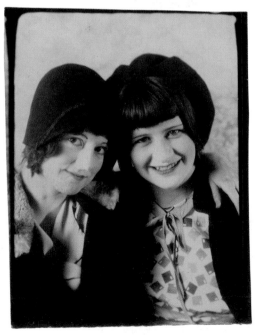

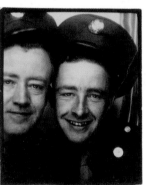

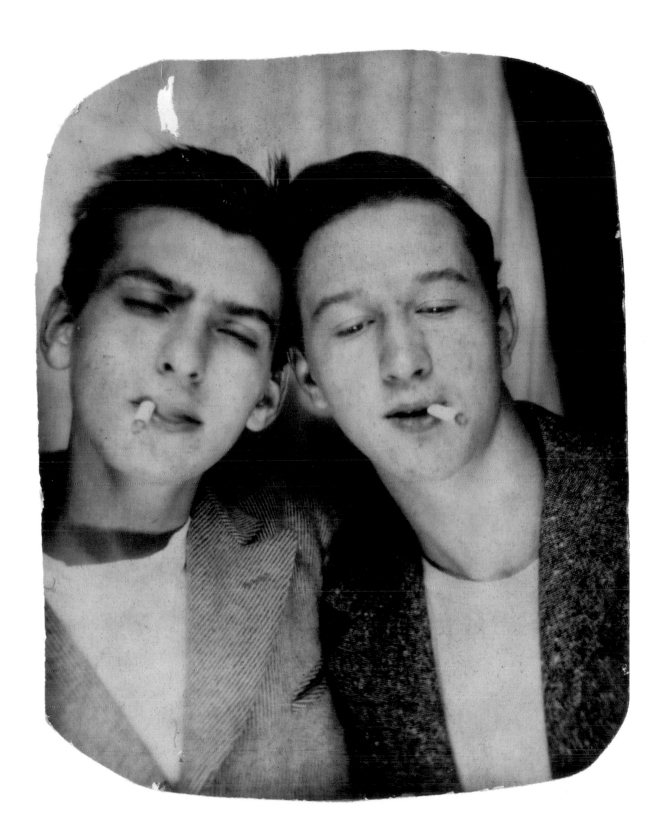

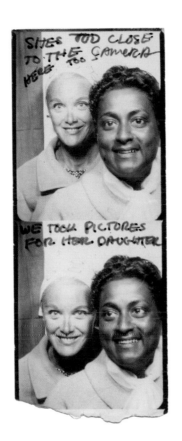

SHES TOO CLOSE
TO THE CAMERA
HERE TOO

WE TOOK PICTURES
FOR HER DAUGHTER

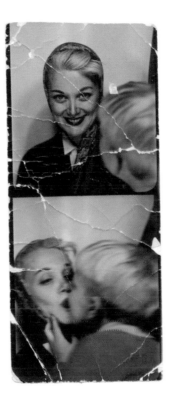

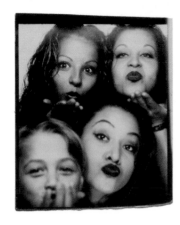

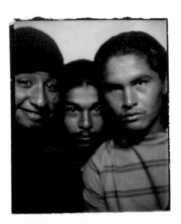

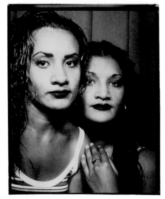

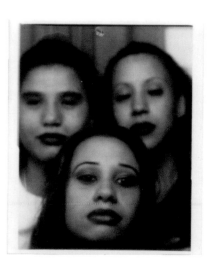

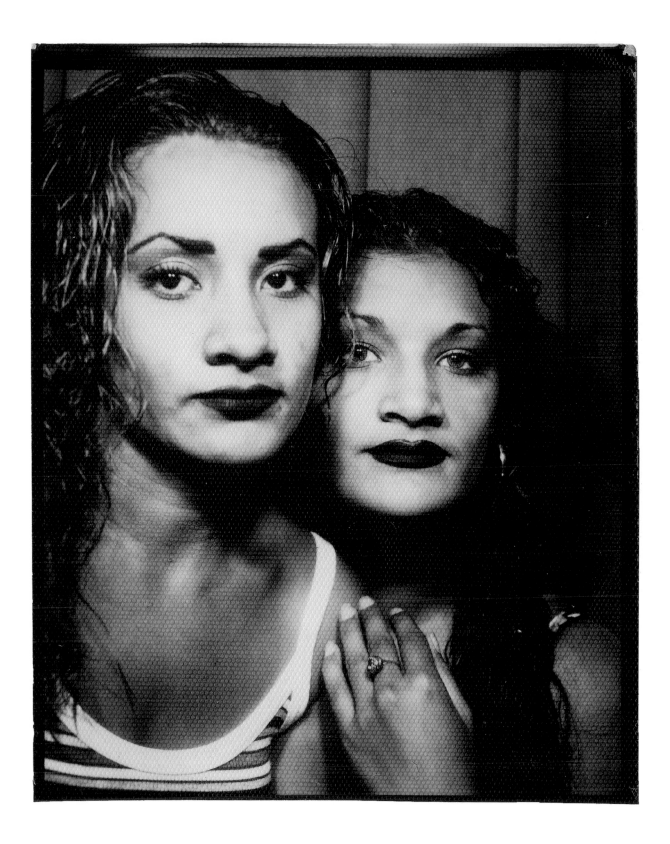

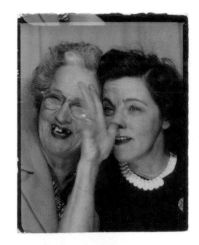
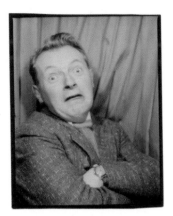
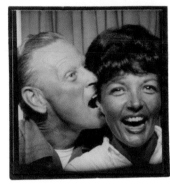
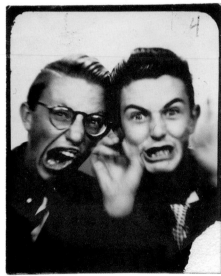
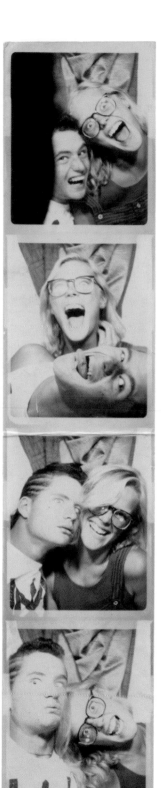

118

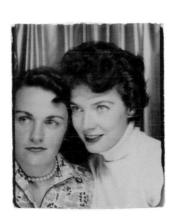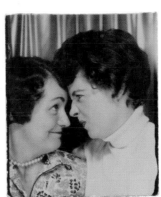

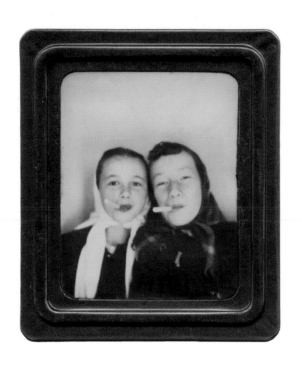

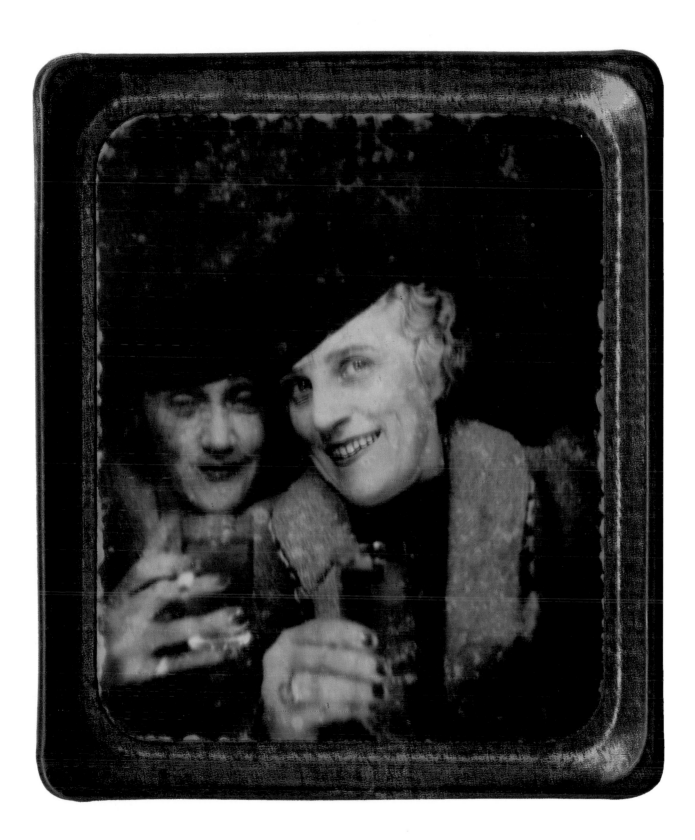

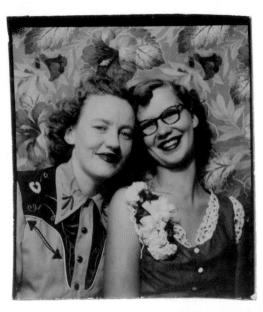

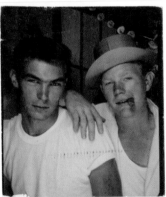

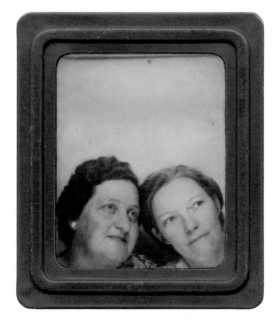

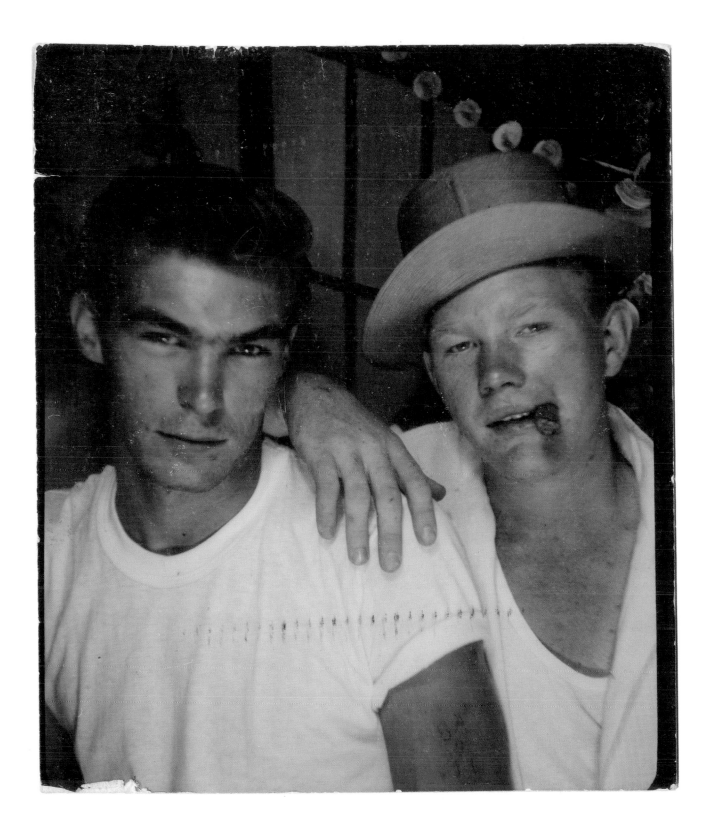

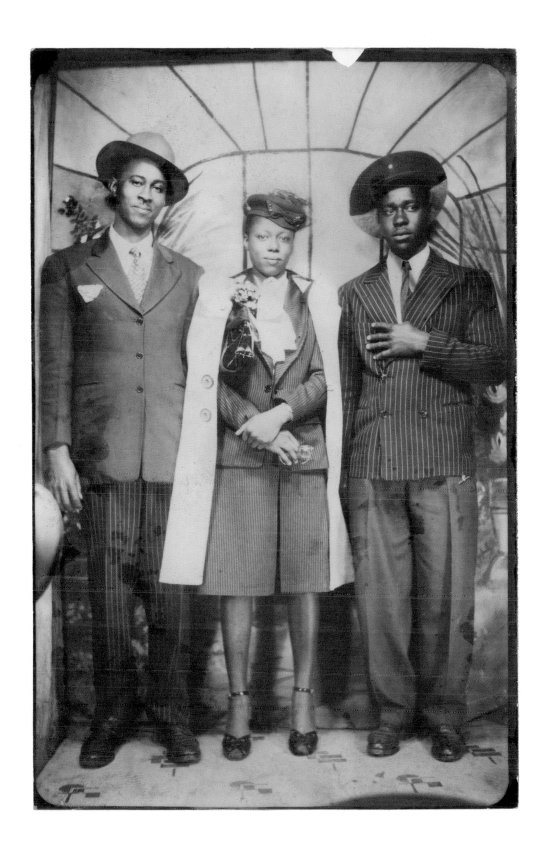

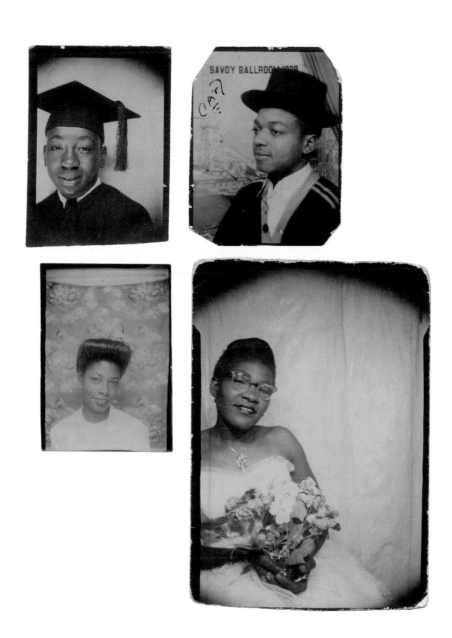

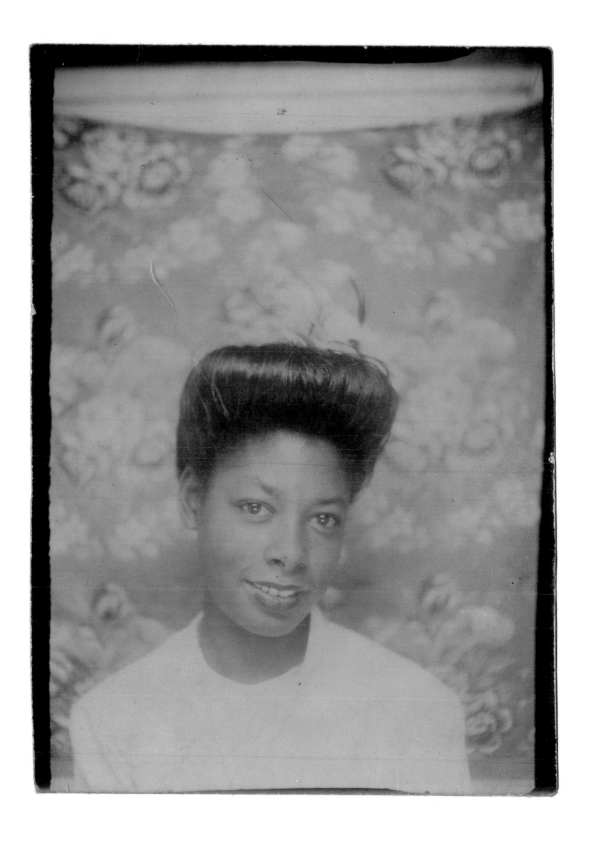

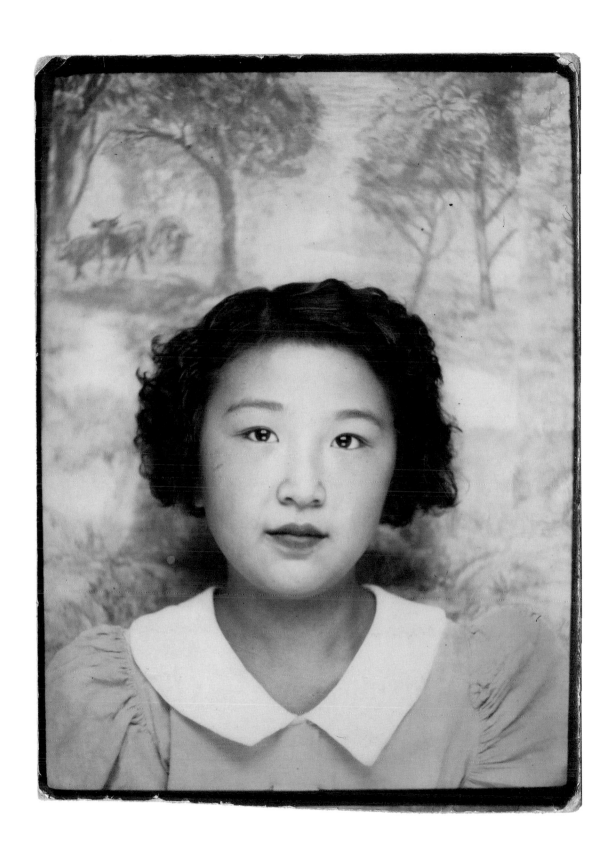

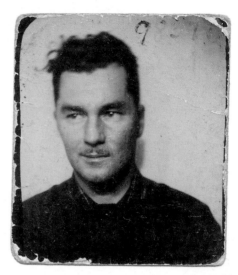
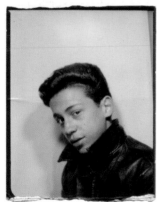
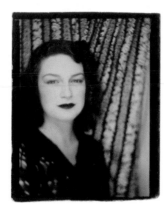
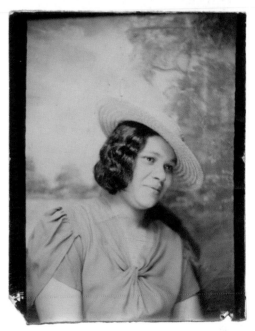

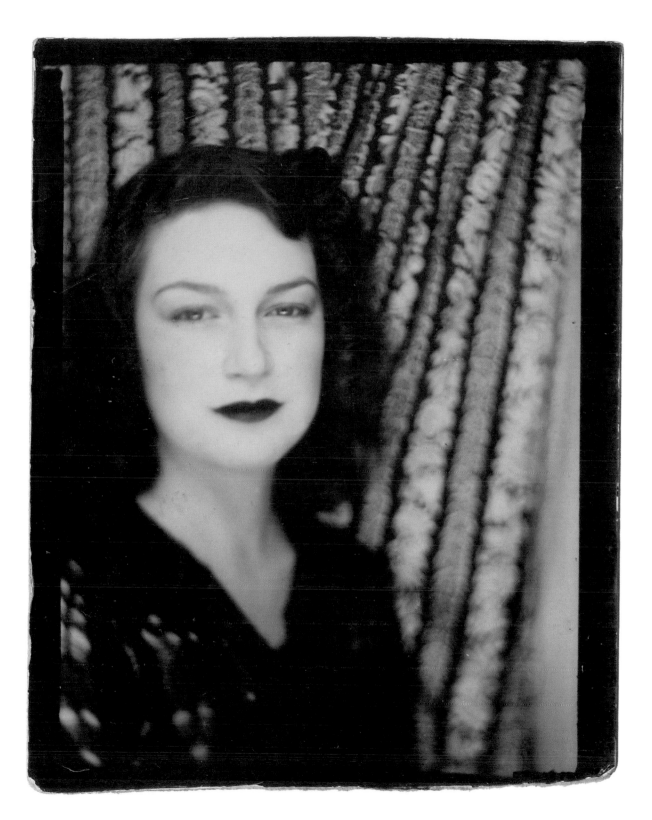

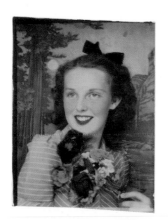

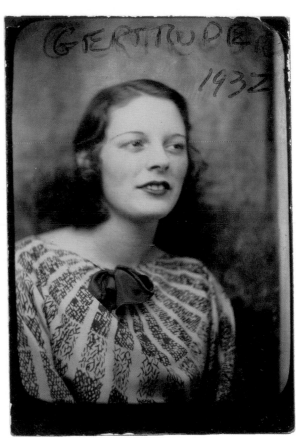

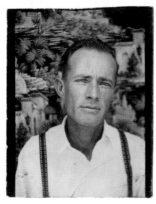

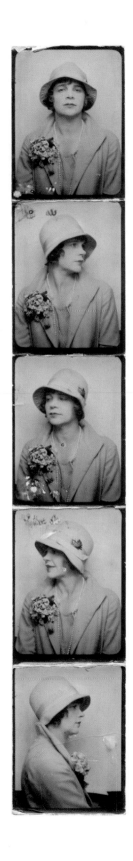

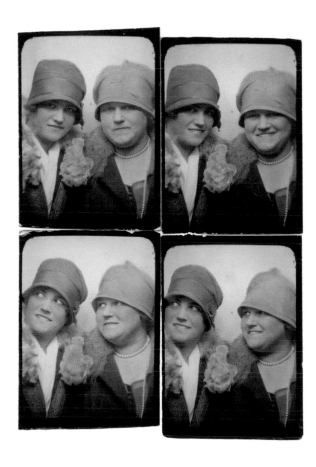

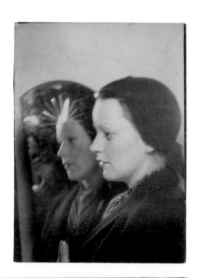

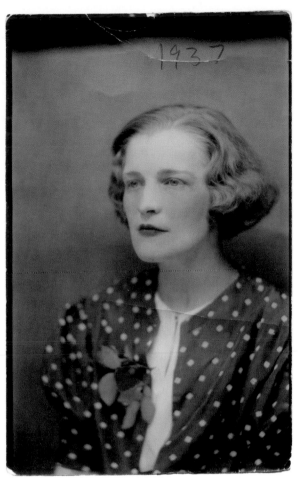

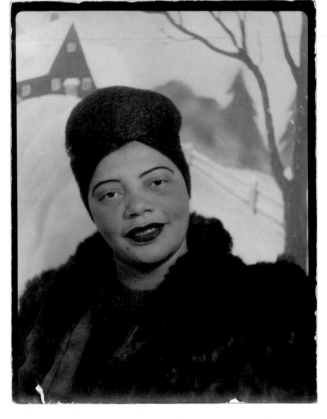

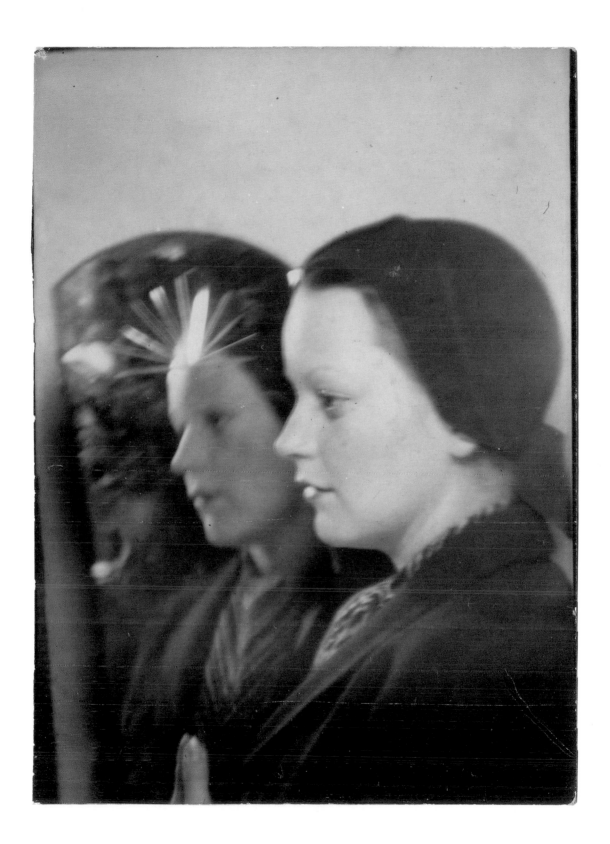

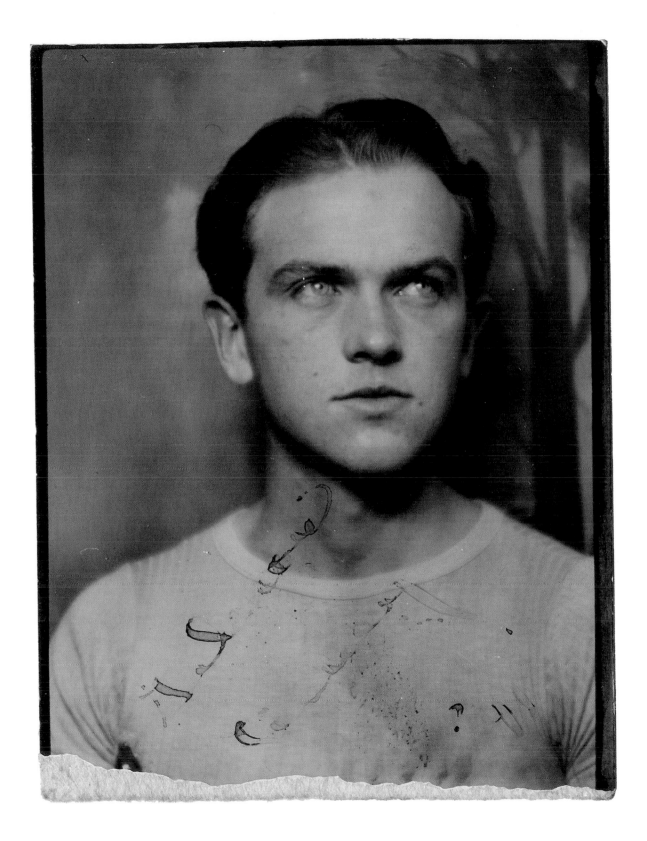

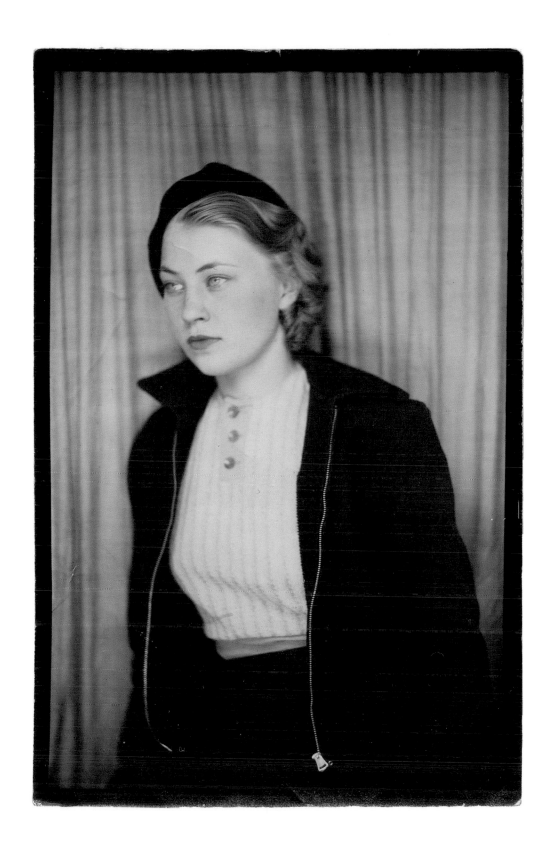

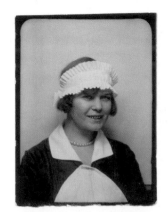

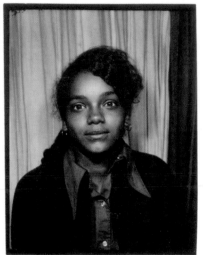

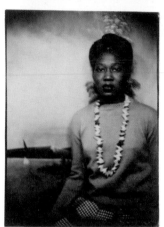

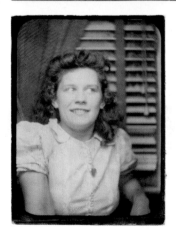

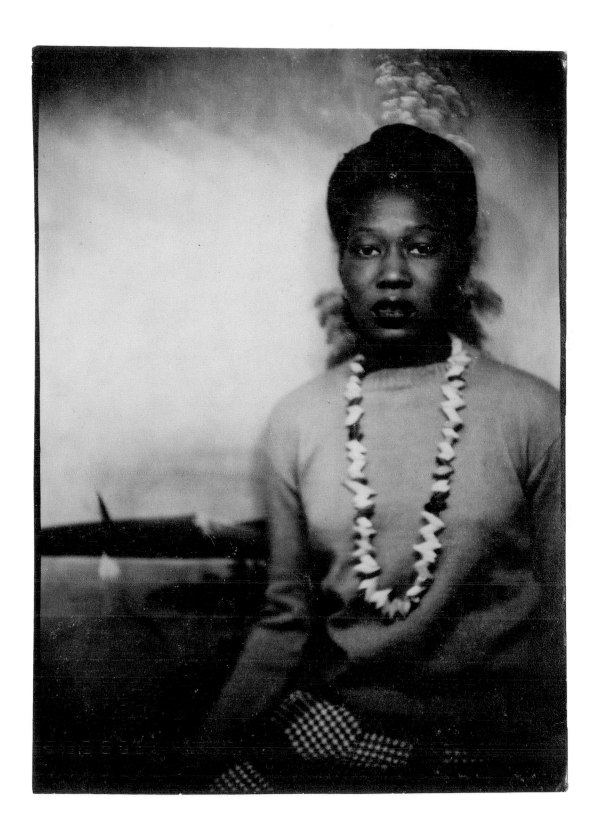

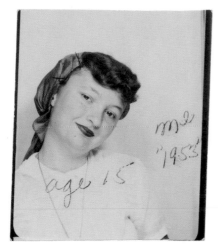

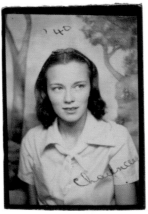

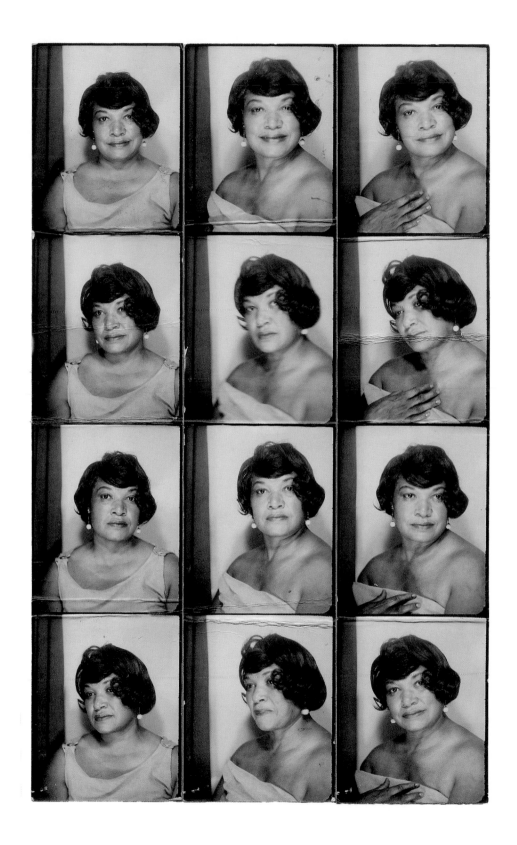

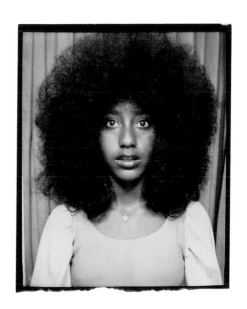

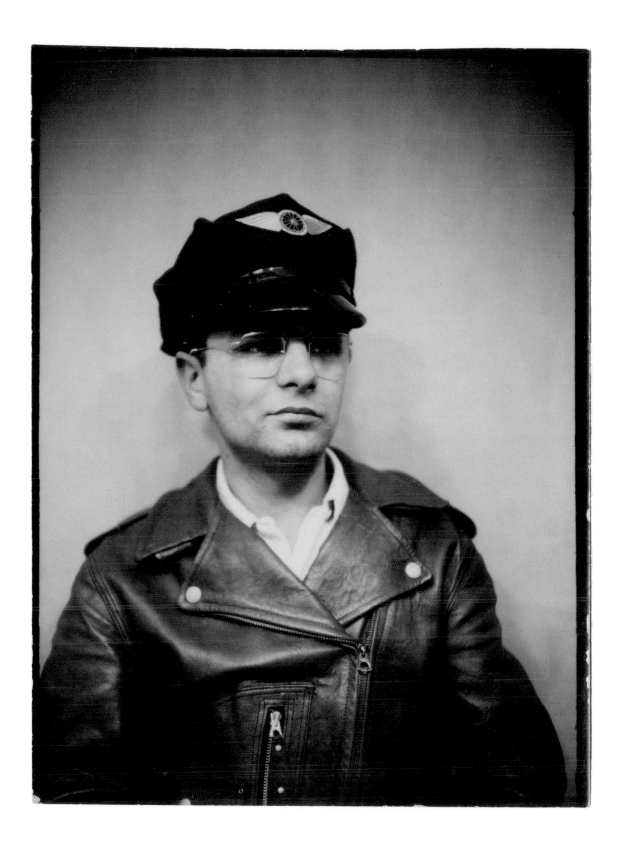

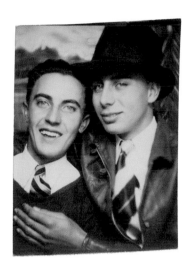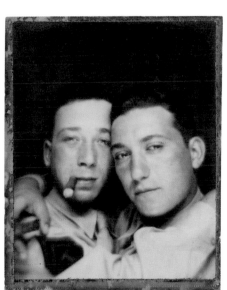

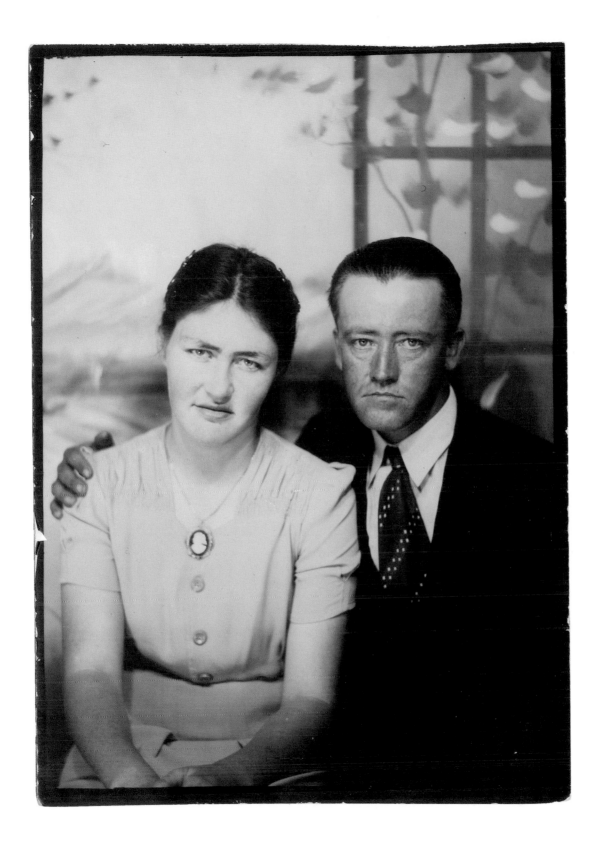

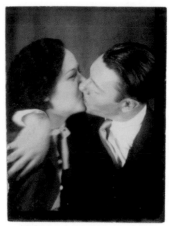

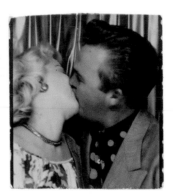

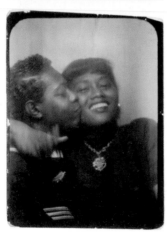

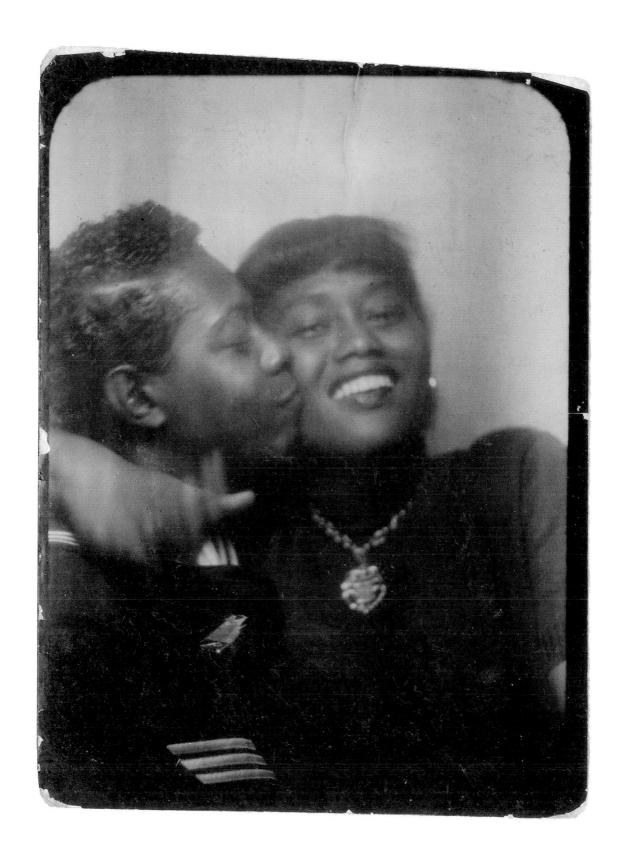

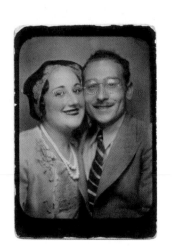

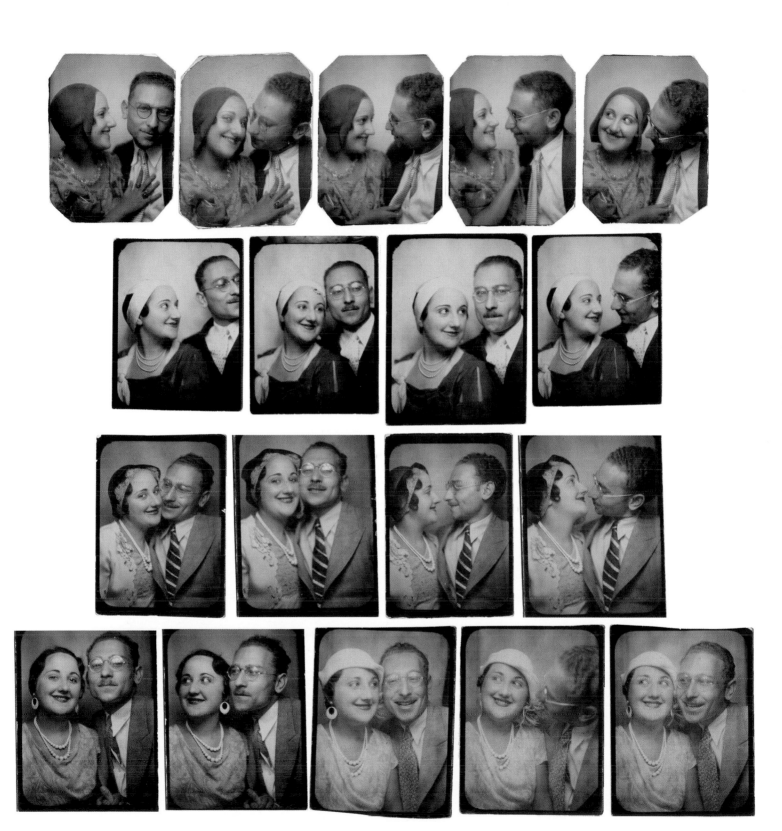

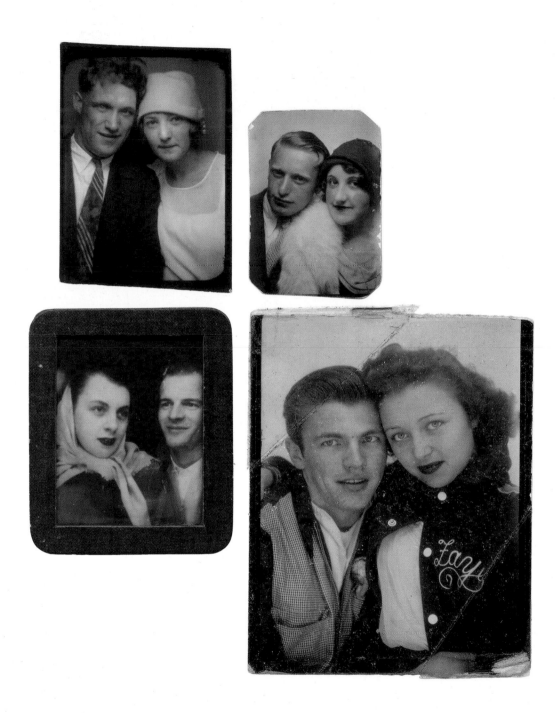

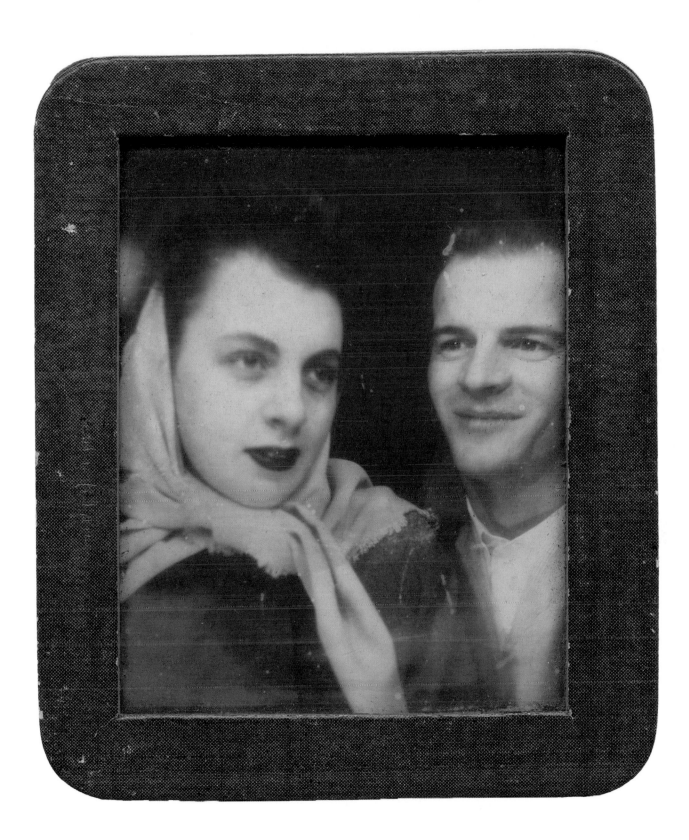

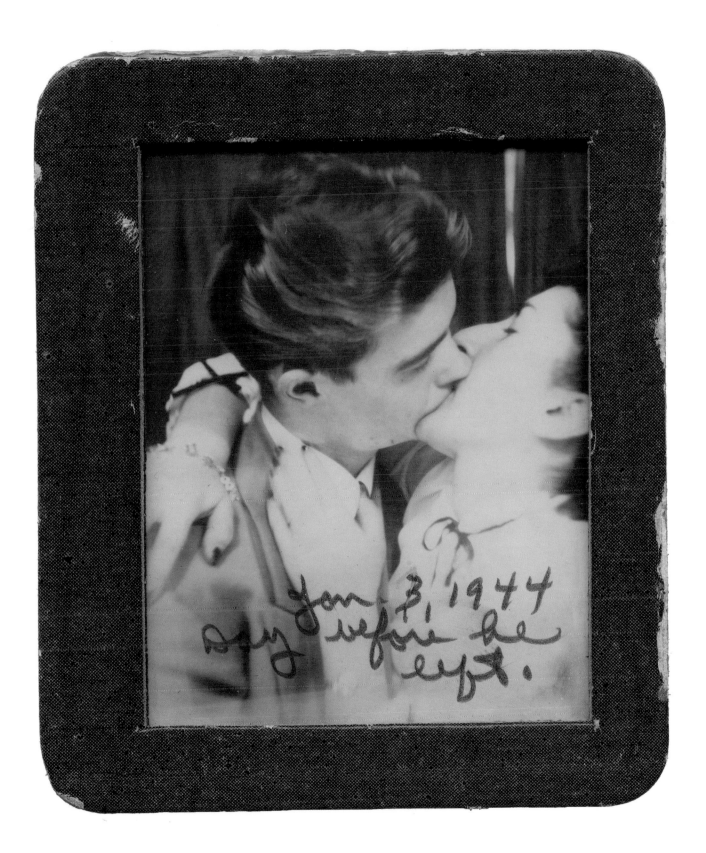

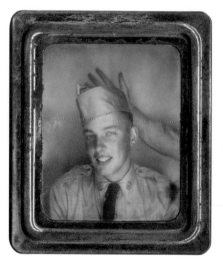 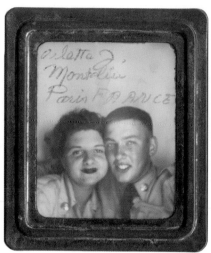 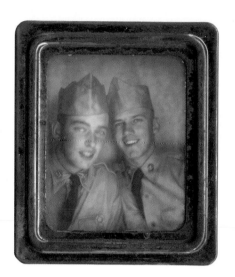

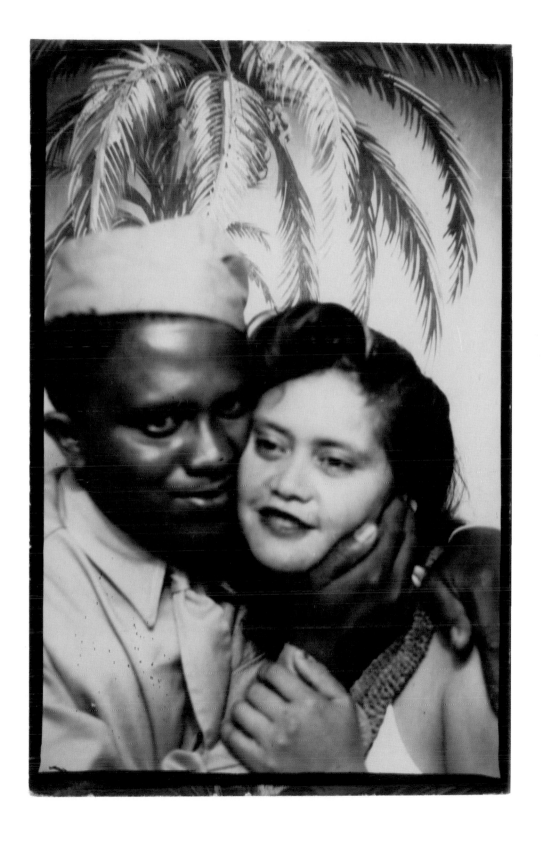

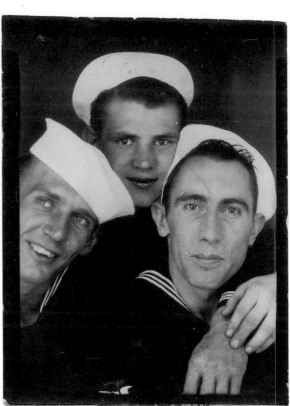
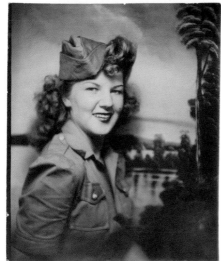
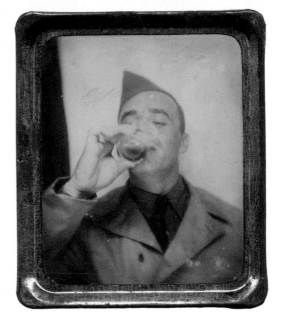

166

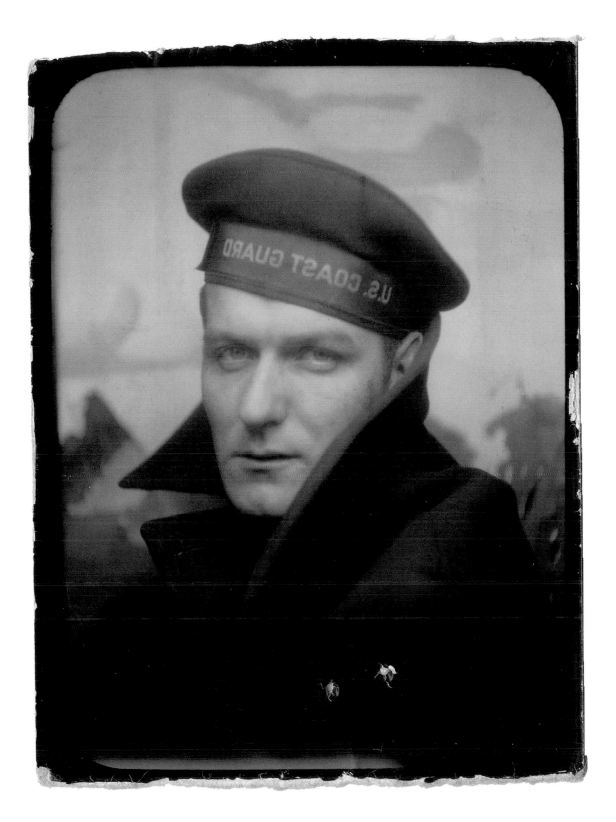

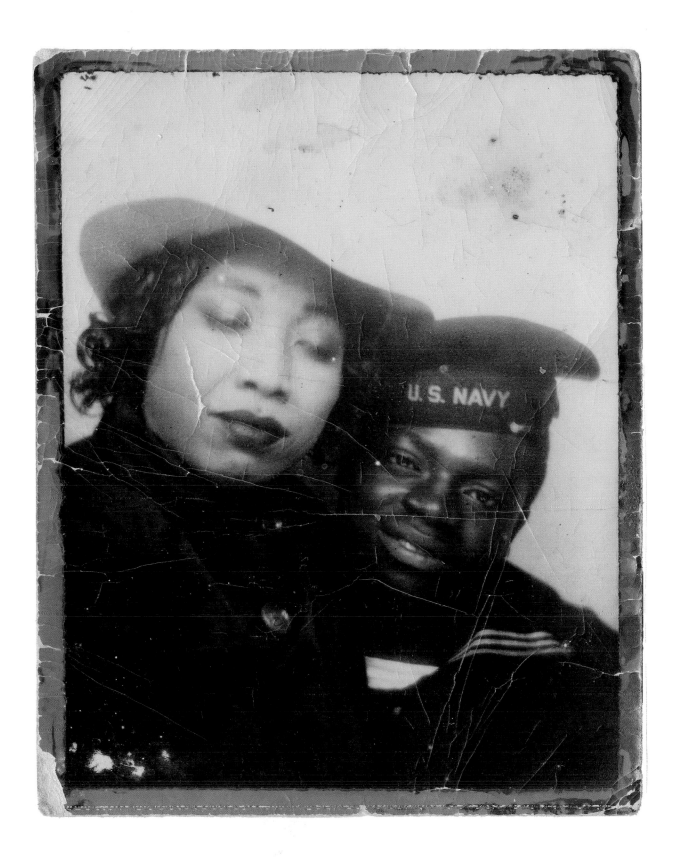

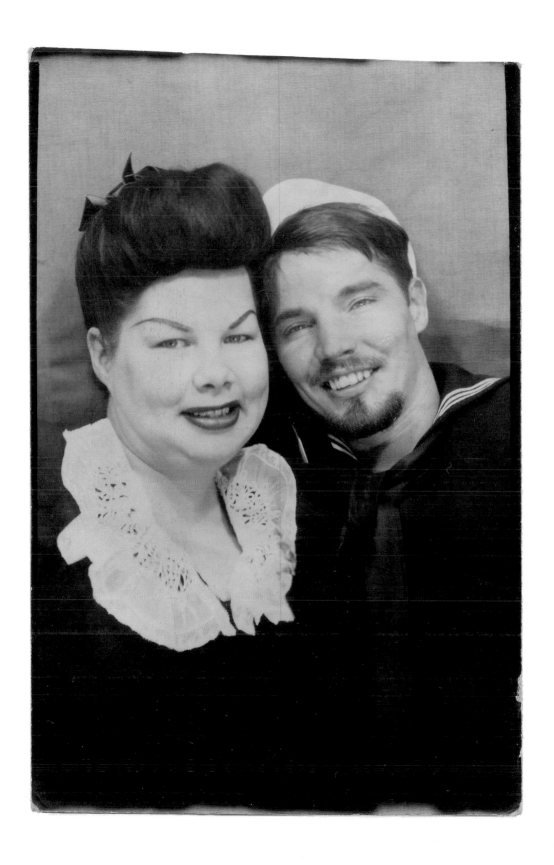

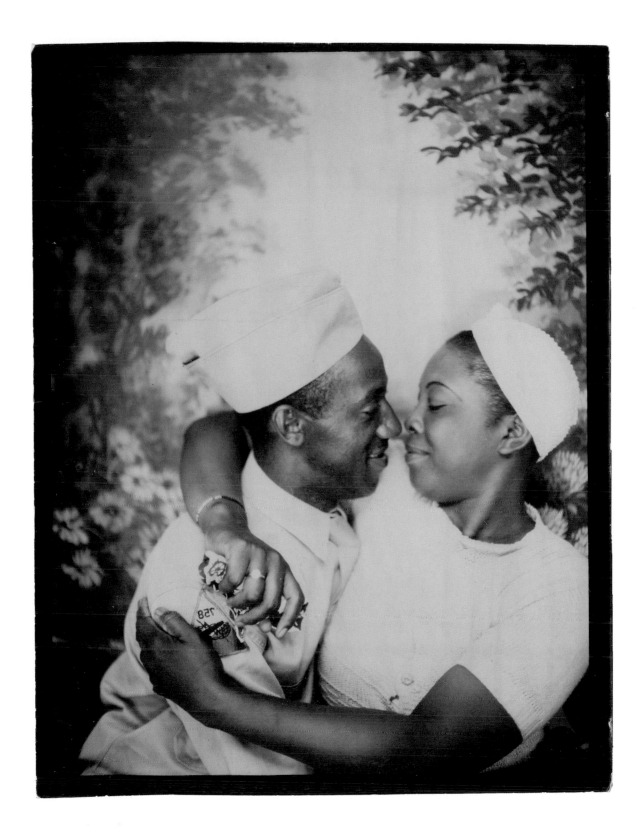

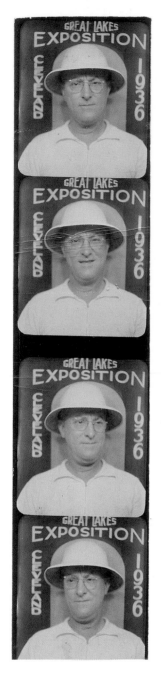

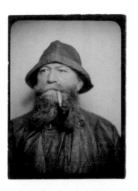

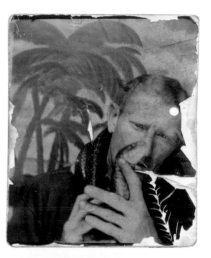

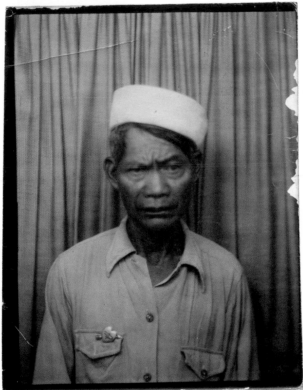

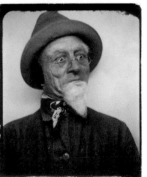

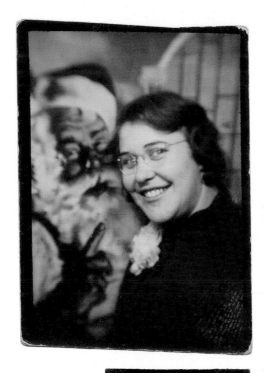

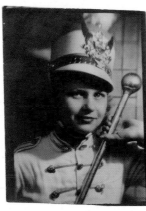

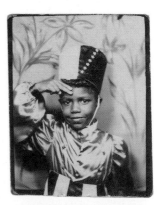

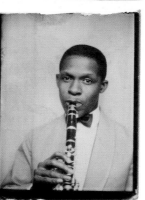

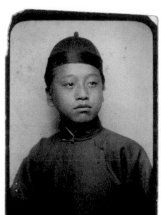

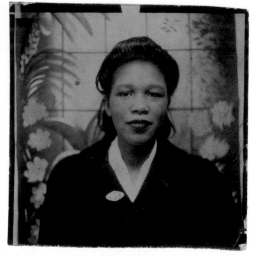

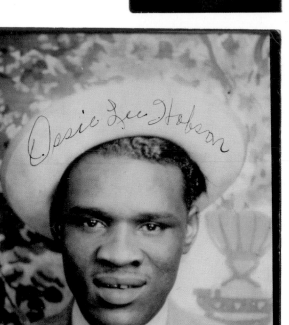

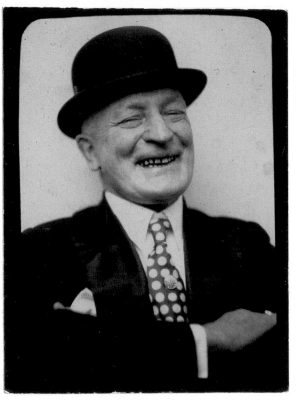

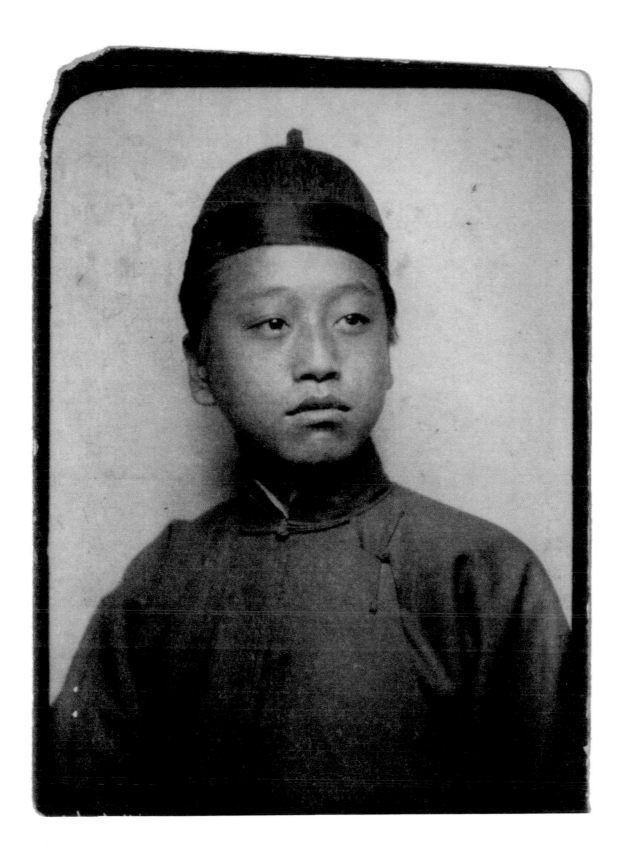

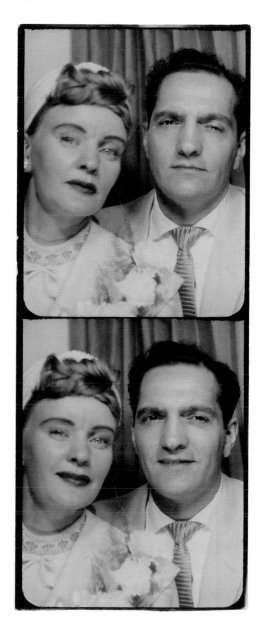

Nov. 19, 1959
Chinatown
L.A., Calif.
Wedding
night.

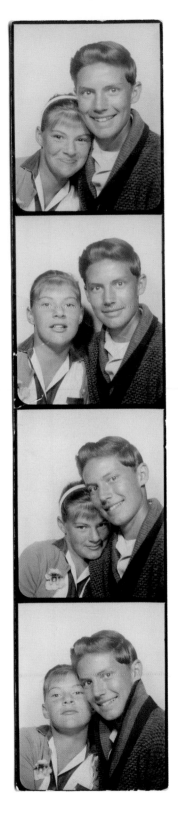

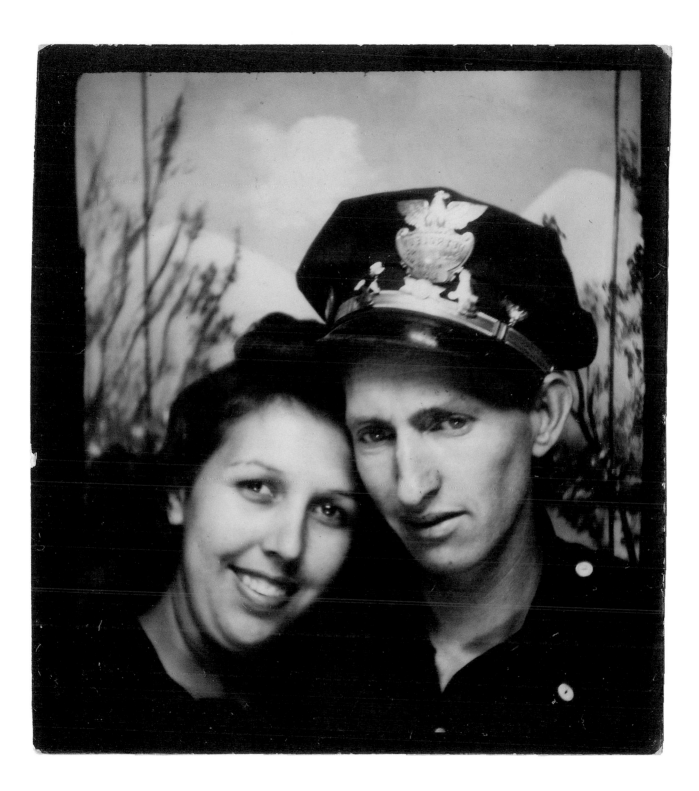

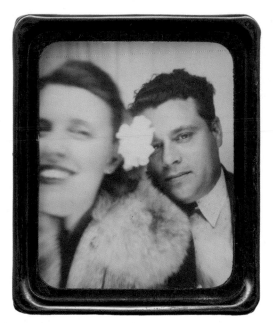
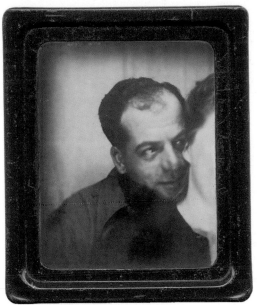
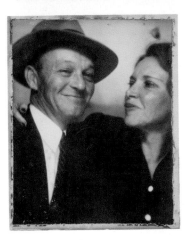

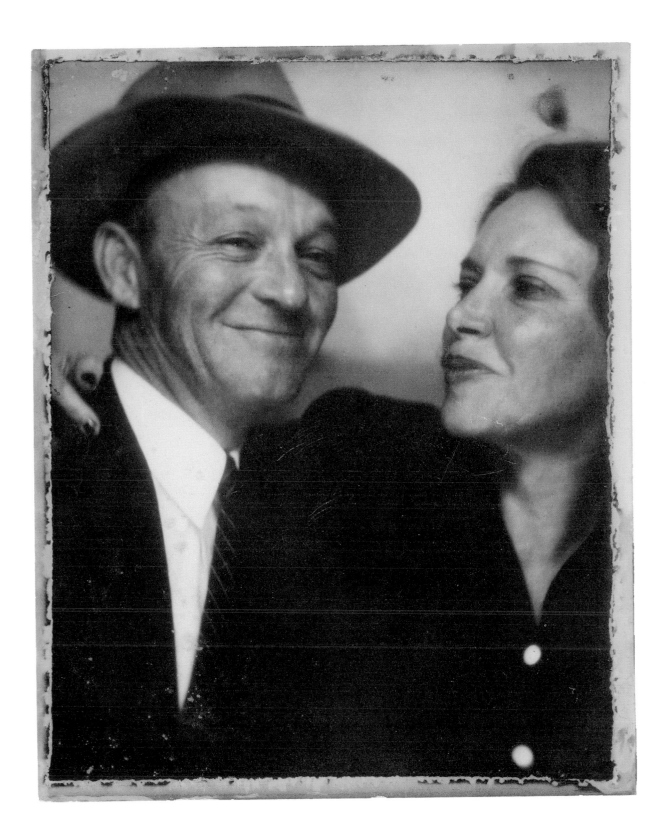

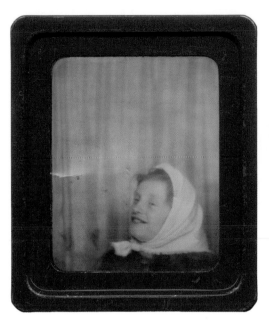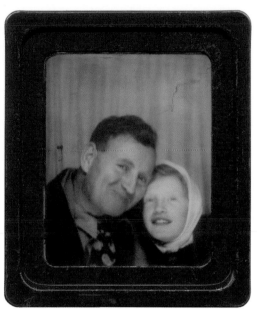

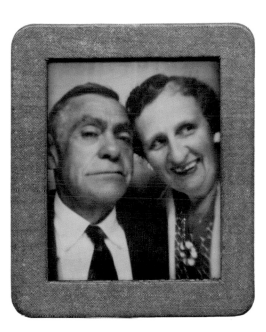 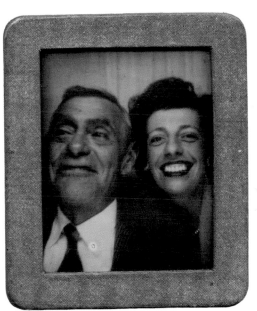

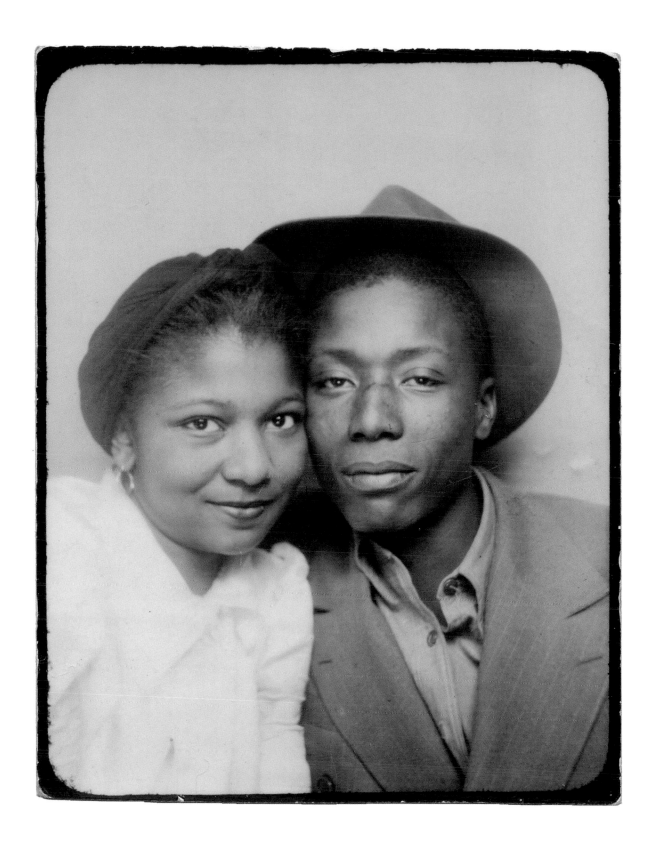

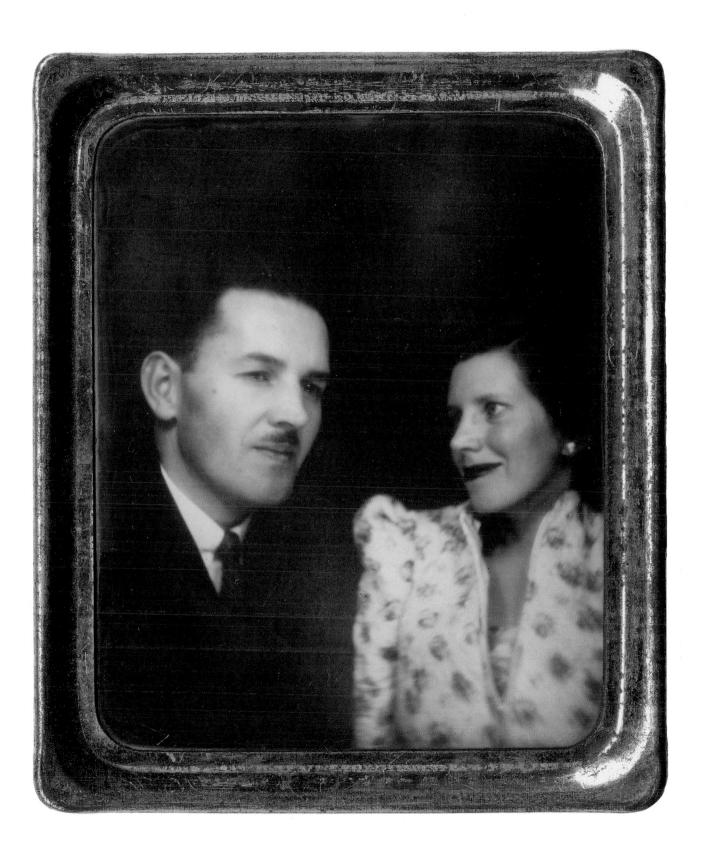

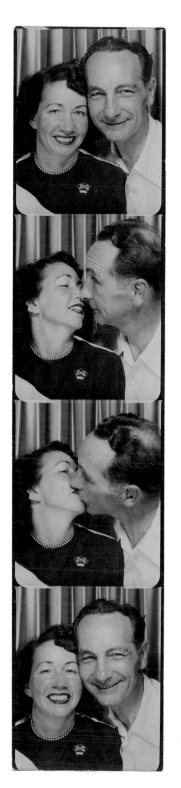

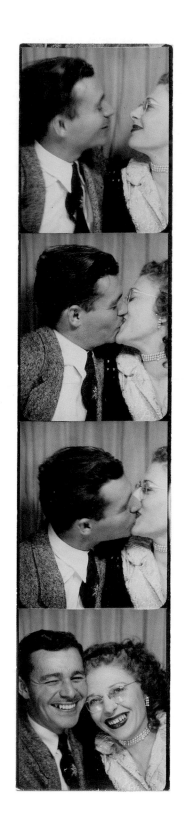

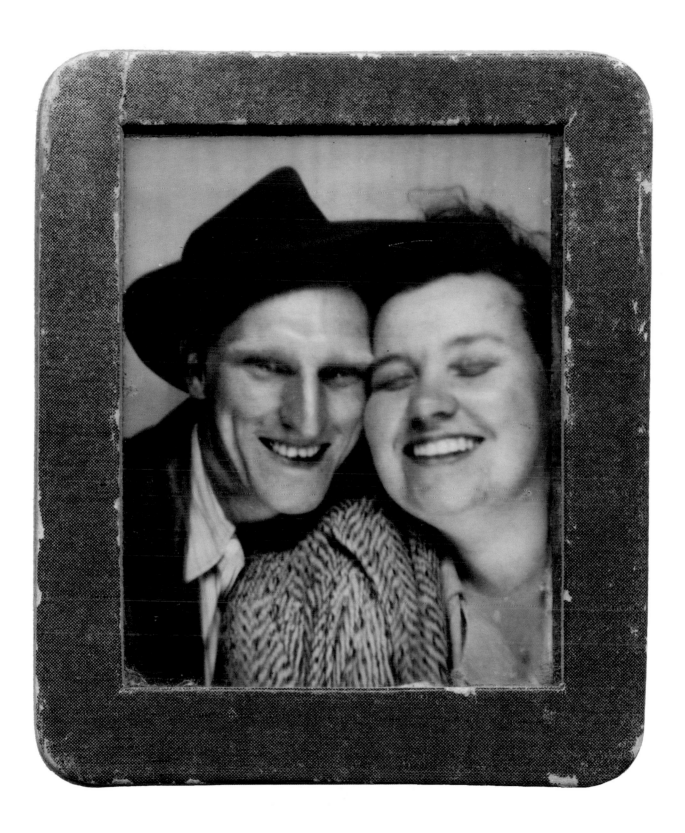

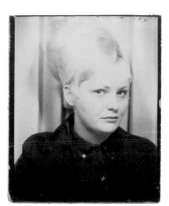

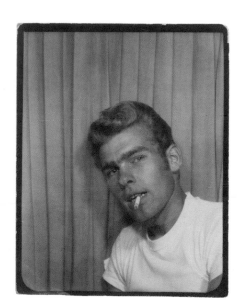

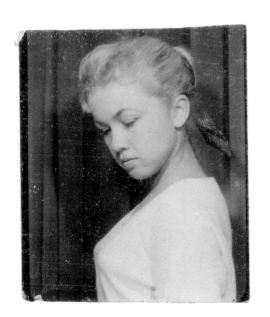
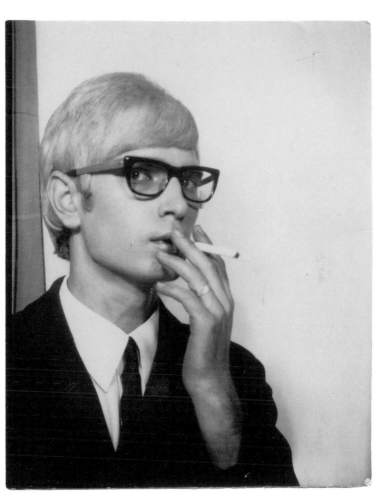

B

Lyin in
Bed at 3:30
Just cant
stop thinking
 I'm gonna
get better
the hard way
Dont wanna
Die that
WAY

I'll get
my pride
pumpen agin
handle life
the way
i WANT

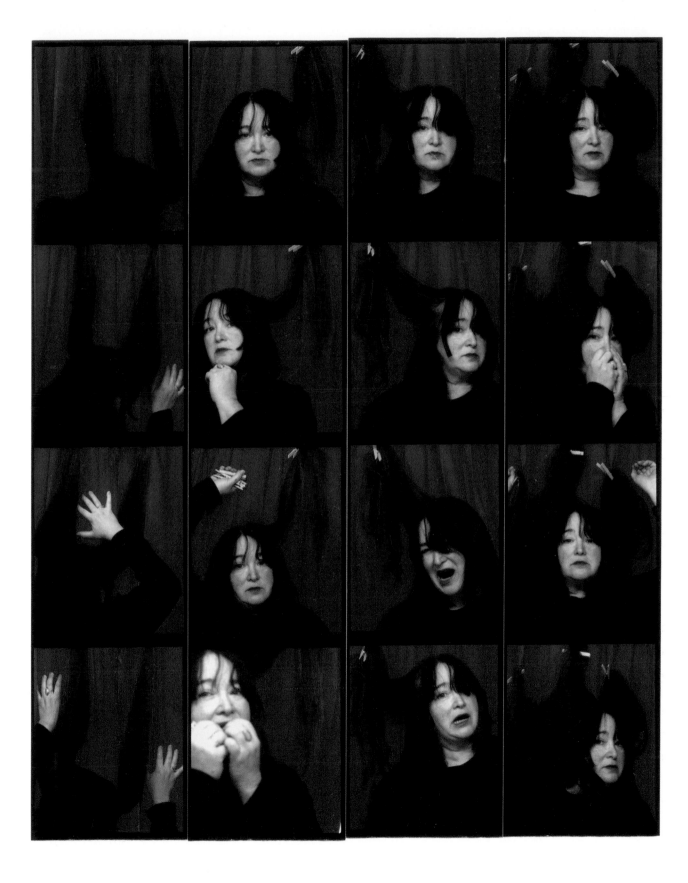

ACKNOWLEDGMENTS

This book deals primarily with the photobooths in North America. However, I would be remiss not to mention Steve Howard, Mister Mix-Up of England, who has been a longtime promoter of photobooth art and the founder of the International Photobooth Convention.

In addition, there are other photobooth artists around the world whom I would like to mention: Susan Hiller, Liz Rideal, and Billy Childish in England, Tomoko Sawada of Japan, Rolf Behme and Jan Wenzel of Germany, Marc Belini, Luc Delahaye, and Cendrillon Belanger of France, Paul Yates of New York, Tim Garrett of St. Louis, and the late Lee Goodie of Chicago. This is by no means an end-all of lists. I am hopeful that I will hear from other working artists.

Because there were so many small independent photobooth companies in the 1930s, '40s, and '50s, with few records left behind except for the photo strips, the names of individuals and companies have been lost in time. I would be grateful, if such information exists, if people would get in touch with me and I will include those names and pertinent information in subsequent editions.

I want to acknowledge and thank the following individuals who have contributed to this book in one of a number of ways—through telephone calls, correspondence, and meetings, use of photographs and family papers, or encouragement. If I have inadvertently left anyone out, I take full responsibility: First, I would like to thank my editor at Norton, Jim Mairs, for his keen, incisive eye, his understanding and support of my project, and his true love of photography. To his assistant, Austin O'Driscoll, for her cheerful support of all my questions, her genuine enthusiasm, and her ongoing help. A big thank you to Laura Lindgren for her lovely design work, sense of humor, and patience. Andrew Allen Smith for his generous sharing of the Bailey photowagon photograph;

Näkki Goranin, photobooth self-portrait project, 2004.

Susan Cox and Frank Biancalana for the many hours spent in reviewing both the text and photos; Stephen Stinehour, in addition to production work, for the suggestion of writing the history and taking all my hundreds of phone calls; Michael Augustine, Gene Lipkin, Paul Kadillac, Gary Gulley, Matthew Carter, Todd Erickson for his use of beer-drinking photobooth photo and for lessons in photobooth repair, Norm Pink for the hours spent sharing much of the history of Auto-Photo; Jim Henderson, Dan David, Peter McCowan, Jim McCowan, and Ruth McCowan for sharing their home and memories of the Phototeria; Jeffrey Slack for climbing into the garbage and retrieving his father's photos and records; the Slack family; all the people at Photo-Me in Texas; Piper Smith, who started me on the road to publishing this book; Gilbert Hemmeter, Eddie Adlum, Ray Delacruz, George Grostern, and George Gilbert for use of his Photomatic booth photograph; and Herman Costa, George Berticevich, Alberto Caroselli, Rodger Kingston for use of his automatic photomachine photo, Marty Rabkin and his recollections of his father, friends of Anatol Josepho, Shannon Perich and Michelle Delaney at the Smithsonian, David Roby, Nicholas and Marilyn Graver, Lora Bailey Zibman, Jamie Bailey Zibman, Larry Beiza for sharing information about the Mutoscope photobooths, Linda Duchin, David Haberstich for his wonderful foreword, Mary Jo Steckevicz, Sonya Webster, Heather Gregorek, Tim Garret, Grant Romer, Betty Lou Young, who wrote about Anatol Josepho in her marvelous Rustic Canyon book and who allowed use of a photo of Josepho, and all the wonderful staff at the Burlington post office.

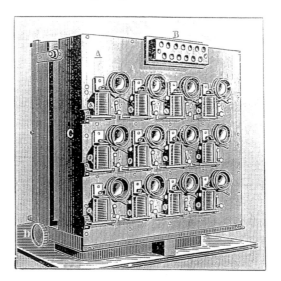

FIG. 107.—CAMERA.

Early gem-style camera, used originally for tintypes and later adapted to paper images, similar to automatic machine images.

218

SOURCES

BOOKS AND CATALOGUES

Boyle, Bern, and Linda Duchin. *Photomaton: A Contemporary Survey of Photobooth Art*. Rochester, NY: Pyramid Arts Center, 1987.

Collins, Douglas. *The Story of Kodak*. New York: Harry N. Abrams, 1990.

Fraprie, Frank R., and E. J. Wall, editors. *The American Annual of Photography*, volume xlii. Boston: American Photographic Publishing Co., 1928.

Indiana, Gary. *Andy Warhol Photobooth Pictures*. New York: Robert Miller Gallery, 1989.

Jeunet, Jean-Pierre, Guillaume Laurant, with Phil Casoar. (2001), *Le Fabuleux Album d'Amélie Poulain*. Paris: Editions des Arènes, 2001.

Plunkett-Powell, Karen. *Remembering Woolworth's*. New York: St. Martin's, 2001.

Woodbury, Walter E. *Photographic Amusements*. Boston: American Photographic Publishing Company, 1928.

Young, Betty Lou. *Rustic Canyon and the Story of the Uplifters*. Santa Monica, Calif.: Casa Vieja Press, 1975.

PERIODICALS

Aperture, vol. 89, 1982.

Automatic Age, June 1931, and various issues 1943–1950.

Auto-Photo brochures, 1952–1980.

Billboard, various issues 1935–1941.

British Journal of Photography, December 3, 1926.

The Edison Monthly, October 1926.

Esquire, November 1957.

Game Room Magazine 16, no. 7, July 2004.

Gilbert, George. "Automatic Photography." *Photographica/Journal*, 1986.

Historical Statistics of the U.S.: Colonial Times to 1970, U.S. Department of Commerce.

The International Mutoscope Reel Company, Inc. "The Machine of Tomorrow for Profits Today." Booklet for 1939 New York World's Fair.

The International Mutoscope Reel Company, Inc. *Photomat Manual*, circa 1935–45.

The International Mutoscope Reel Company, Inc. *Photomatic Manual*, circa 1935–45.

Jones, Patti, "Photobooths Still in the Picture." *Milwaukee Journal Sentinel*, December 19, 2002.

Josepho, Anatol. *The Photomaton Manual*, 1926.

Kim, Jae-Ha. "The Incredible Disappearing Photobooth." *Chicago Sun Times*, July 31, 2001.

New York Clipper, February 13, 1904.

Prim, Mary Elizabeth. "Photos without Tears." *Photo Era*, 1926.

Smith, Roberta. "Jared Bark Photo-Booth Pieces." *Art Forum*, 1973.

Note: Articles from the late 1920s detailing Anatol Josepho's early life were available to me from the archives of the Smithsonian Institution. Unfortunately, the names of magazines and exact dates of publication were not always available and so have not been indicated above.

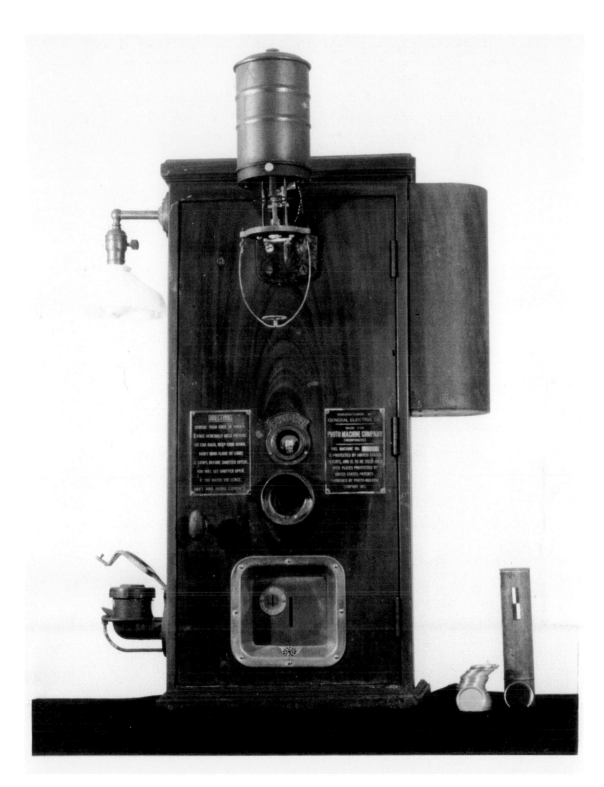

GE photo-tintype machine, circa 1915. Courtesy of George Gilbert.

PHOTOBOOTH SALES AND RENTALS

There is a growing number of places to rent or sell both chemical and digital photobooths. You can Google "photobooth rentals" and find more than 23,000 entries.

For readers outside of North America, there are overseas companies where booths may be rented. In Central and South America and, more recently, Russia, chemical black-and-white booths are readily accessible.

Here is a short list of North American vendors:

A.K. Altman Entertainment
www.photoboothevents.com (tel) 877-518-2266
Traditional chemical photobooths available for the New York and Northeast regions.

Apple Industries
(tel) 718-655-0404
Apple rents a variety of fun digital booths in the New York City area as well as the eastern seaboard.

Auto-Photo Canada Ltd.
5778 Avenue Royalmount, Mont Royal, Canada, QCH4P1KP
Owned by the Grostern Family. Rentals and purchases of photobooths throughout Canada. Also a supplier of photopaper, chemicals, and maintenance.

Fantasy Entertainment
Hudson, New Hampshire (tel) 603-324-3240
This very large and successful company deals only with digital photobooths. They also produce photobooth sketches and a 3-D laser image on chrystal. Machines are available for rental or sale.

Hairstyle Illusions
Jim Henderson
(tel) 949-472-8200
Located in Mission Viejo, California, this company sells and rents a unique photobooth in which sitters have the option to see themselves in different hairstyles. Images may also be manipulated.

Photobooth Memories
2274 University Avenue, St. Paul, Minnesota,
55114 (tel) 612-701-5503
Owned by Todd Erickson, there are fifty
black-and-white vintage photobooths avail-
able for rental. Mr. Erickson is also a master
maintenance technician.

Photobooth STL
(tel) 314-322-6680
This St. Louis company, run by Tim Garrett,
rents black-and-white chemistry booths and
a neat retro digital photobooth (designed by
Tim, the owner) that prints glossy four-by-six
prints instead of a strip.

Photo-Me U.S.A.
www.photo-me.com (tel) 888-746-8663
With headquarters located in Texas, this is
the oldest surviving photobooth company.
Established over half a century ago, this
company offers rentals, purchases, and
maintenance of photobooths throughout the
United States. This is also the headquarters
in the United States for ordering paper and
chemicals.

Photo-Works Interactive
(tel) 800-990-8445
West Coast photobooth sales and rentals;
both black-and-white and color booths avail-
able. The big seller is the Model 12, which
produces digital strips.

Websites of Interest
Steve Howard's website: www.mixup.org.uk/

www.photobooth.net

My own website: www.nakkigoranin.com

Thanks Mom